Acknowledgements

Thanks to: The staff of the Local Studies departments at Sheffield, Rotherham, Doncaster and Barnsley Central Libraries, the South Yorkshire Archaeology Service, Peter Clarke and Ray Ellison of the Grenoside Sword Dance team, David Bostwick, Andy Roberts, Andrew Slater, Peter Hague and the staff of *The Weekly Trader, Sheffield Newspapers Ltd, The Rotherham Advertiser,* Nigel Watson, Joe Sheehan, Claire Lawrence, Joe Atkins, Phil Reeder, Rob Wilson, Dick Ellis, Kevin Turton, Georgina Boyes – and anyone I have missed out!

Frontispiece: The legendary dragon of Wantley, killed by More of More Hall (courtesy: Sheffield City Libraries)

STRANGE SOUTH YORKSHIRE:
an alternative guidebook

David Clarke

Published by Sigma Leisure – an imprint of
Sigma Press, 1 South Oak Lane, Wilmslow, Cheshire SK9 6AR, England.

British Library Cataloguing in Publication Data
A CIP record for this book is available from the British Library.

ISBN: 1-85058-404-4

Typesetting and Design by: Sigma Press, Wilmslow, Cheshire.

Cover: illustration by Martin Mills, based on the mysterious sundial in the churchyard at Thorpe Salvin, near Rotherham. Courtesy Sheffield City Libraries.

Printed by: Interprint Ltd., Malta

Preface

"In the pleasant district of merry England which is watered by the River Don, there extended in ancient times a large forest covering the greater part of the beautiful hills and valleys which lie between Sheffield and the pleasant town of Doncaster. The remains of this extensive wood are still to be seen at the noble seats of Wentworth, of Wharncliffe Park, and around Rotherham. Here haunted of yore the fabulous Dragon of Wantley; here were fought many of the most desperate battles during the Civil Wars of the Roses; and here flourished in ancient times those bands of gallant outlaws, whose deeds have been rendered so popular in English song . . ." *Ivanhoe* by Sir Walter Scott

Welcome to 'Strange South Yorkshire' - a guidebook to the mysteries, strange happenings, folklore and legends of this beautiful county whose landscape is rich in every aspect of the supernatural magic of ancient Britain.

This book is the result of a demand for an 'alternative guide' to the city of Sheffield and the surrounding county for those who look beyond the official histories, and whose sense of the region's past is not confined to the 'glories' of industrialisation in the form of coal mining, steel-making and the development of transport and communications. Today many people are seeking to rediscover those hidden things which they believe recent centuries of 'progress' have taken away from them. Despite living in the hi-tech world of the late 20th century, mankind still has a spiritual yearning back to the time when he lived in close harmony with nature, the earth and the changing seasons.

For that reason, this book looks at the history of South Yorkshire from the perspective of Earth Mysteries, a term which includes under its wing a range of alternative knowledge including folklore and legends, ley lines and ancient alignments, ritual landscapes and Pagan religion. Those who study Earth Mysteries today are following in the footsteps of antiquarians who earlier

this century committed many of these folktales to writing for the first time.

One hundred years ago a book called "Household Tales with other Traditional Remains collected in the counties of York, Lincoln, Derby and Nottingham" was published in London and Sheffield. It was the first work of its kind to gather together the traditions and folklore of Sheffield and the surrounding area, at a time when many of them were rapidly disappearing.

The author was Sidney Addy, born in Norton in 1848 and educated at the Sheffield Collegiate School and Lincoln College. Those studying the folk tradition of South Yorkshire owe a great debt to his work, and this book draws heavily upon his sadly neglected writings. Addy was 'a solicitor by profession, but an antiquarian by instinct' and one of the pioneer field researchers of his day. He recorded many of the older beliefs of this region including legends and traditions, stories about ghosts, fairies and giants, the folklore of stones, water and trees, most of which are forgotten today.

His approach to the study of these subjects was to see them as survivals of belief connected with pagan deities and the changing seasons which had lingered among country dwellers in the more remote parts of South Yorkshire. This kind of approach to the study of folklore is not popular with academics at the moment, but Addy's ideas remain as fresh and relevant today as they were one hundred years ago. Now, people still see ghosts, 'urban folklore' is very much alive in the towns and cities of the region, and there is even a new and thriving layer of belief enriching the great legacy of superstition from the past – that is, belief in Unidentified Flying Objects (UFOs) and Space Aliens.

South Yorkshire is incredibly rich in every aspect of the strange and mysterious, and this work is another attempt to bring together the threads of human experiences with 'The Unknown' from the very earliest times to the present day. In the process, much has to be left out, and I have only been able to skim the surface of the vast pool of human belief and experience which is Strange South Yorkshire.

David Clarke

Contents

1. Earth Magic **1**
In the Beginning . . . 1
Secrets of the Lady Chapel 5
The Head Stone or Stump John 14
Seven Stones on Hordron Edge 17
Churches on Pagan ground 18

2. Robin of Loxley **26**
The Green Man 33

3. Mysteries of Wells and Water **38**
Spaw Wells 39
Holy Wells 44
Water Deities 46

4. Into the Dragon's Lair **53**
The Dragon of Wantley 56
More of More Hall 62

5. The Dark Months **69**
Cakin Night 70
Midwinter and Christmas Customs 72
 The Sword Dancers 72
 The Old Tup 76
 The Bull Week 80

6. The Haunted Realm 83
Barghasts and Boggards 87
The Gabriel Hounds 90
Manor Lodge and the "Hall in the Ponds" 91

7. Subterranean South Yorkshire 95
The Ghost Tunnel 102

8. A Selection of Spooky Tales from South Yorkshire 109
The Park Ghost, or 'Spring-Heeled Jack' 109
Attercliffe Common 113
Ghosts down the Pits 116
The Kimberworth Murders Ghost 117
Phantoms of the Stocksbridge Bypass 120

9. UFOs over South Yorkshire 127
The 1962 UFO Wave 130
Close Encounters 133
The Strange Tale of the UFO 'Road Runner' at Loxley. 133
Aliens over the Co-op! 134

REFERENCE SECTION

A Visitor's Guide to Strange South Yorkshire 139
Museums 139
Places of Historical Interest 140
Some Public Houses with Spirits! 141

Further Reading 143

Contact Addresses 145

Index 147

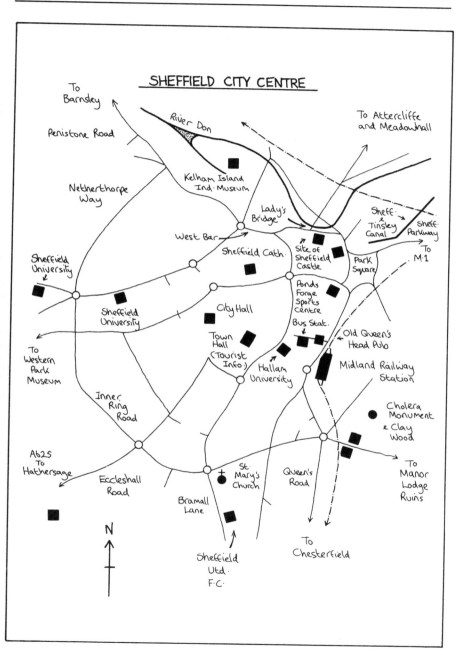

SHEFFIELD CITY CENTRE

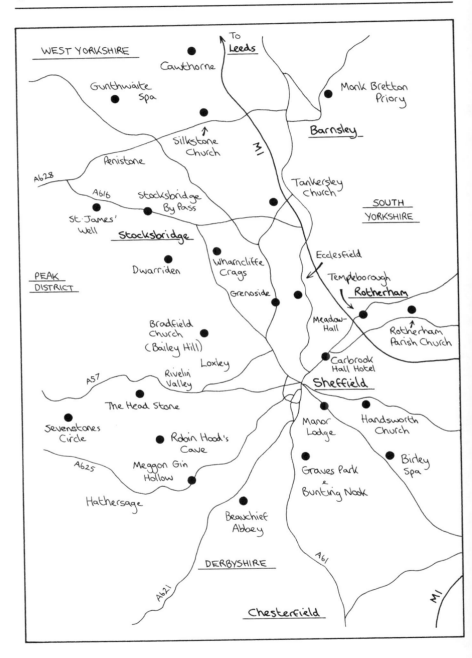

1

Earth Magic

In the Beginning . . .

One thousand nine hundred and forty years ago, infantry and cavalry soldiers from the Fourth Cohort of Gauls, an auxiliary unit of the Roman invasion army, arrived at the border region which today has become the county of South Yorkshire. These strangers in a strange land built a wooden fort at a strategic point on the southern bank of the River Don now known as Templeborough, opposite the native stronghold on Wincobank Hill.

At this time, the valley of the Don (from Danu, a Mother Goddess) was part of an area known to the Romans as Brigantia, a wild region stretching from the Scottish lowlands to Peak District. This area was inhabited by a strong and obstinate confederation of Celtic tribes who called themselves the Brigantes, from another name of the goddess they worshipped – Brigantia, "The High One".

When the Romans left, abandoning their forts at Templeborough and Doncaster (Danum) four hundred years later, the region reverted to the control of the Celtic tribe known as the people of Elmet, until they in turn were overrun by Anglo-Saxon warriors and settlers in the 7th century AD.

During the Dark Ages, South Yorkshire remained on a precarious boundary between the two Anglo-Saxon kingdoms of Mercia and Northumbria, a border which followed the River Sheaf "the boundary river" and the Meersbrook (*mere* meaning "boundary"). It was here that the King of Northumbria and the Danes of Mercia submitted in 942 AD to the King of Wessex "as far as where Dore divides".

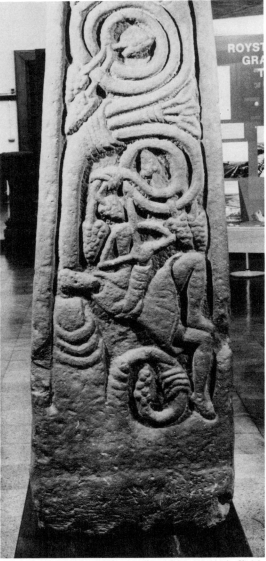

The Sheffield Cross, Weston Park Museum, Sheffield. This is a plaster cast of the original Anglo-Saxon one that is in the British Museum. (Copyright Sheffield Museums Service)

It was from this time the ancient name "Hallamshire" originated as a Saxon shire which included the parishes of Sheffield, Ecclesfield, Bradfield and later, the manor of Handsworth.

We begin our tour of the mysterious landscape of South Yorkshire in the heart of the parish of Sheffield, the centre of a conurbation which is today home to three quarters of a million human souls, and the former industrial heartland of the county.

Urban and industrial development over the last three hundred years have obliterated traces of the original settlement which grew up on the banks of the River Sheaf in Anglo-Saxon times. The river gave its name to the present city "Sceathfeld", meaning a field or clearing near the confluence of the rivers Sheaf and Don.

If it were possible for us to travel back in time one thousand

years what is now Sheffield would appear as cluster of wooden huts gathered around the hall of the Saxon lord on a mound by the river crossing. Not far away a wooden chapel or temple would have stood in a clearing surrounded by forests. At this time the powerful Earl Waltheof, son of a Danish warrior, Sigward the Strong, was Lord of Hallamshire and his stronghold was at the confluence of the rivers near the The Bridge of Our Lady, which stood over "the Watyr of the Dune neghe the Castell of Sheffield."

Earl Waltheof was beheaded in London in 1076 after he took part in a second rebellion against the Norman invader, William the Conqueror, and his widow Judith rented Hallamshire to the first lord of Hallam, Roger de Busli. He was granted extensive lands in South Yorkshire which he ruled from a fortified castle at Tickhill, near Doncaster. A century later, the lands passed to another baron, William de Lovetot who is credited as the founder of the town of Sheffield, which he made his home.

Lovetot built a moated castle over the ruins of Waltheof's wooden hall around 1150, and soon a small town began to spring up around the castle walls, with a vast Park, a corn mill and a hospital for the relief of the poor at Spital Fields. The castle was finally destroyed at the end of the English Civil war and its remains are now covered by the Castle Market building.

When Christianity first arrived in Hallamshire is a mystery, for there is no mention of a church at Sheffield in the Domesday survey of 1086. We do not know if the Celtic temples indicated by the place-names Ecclesfield and Ecclesall had survived, but we can safely assume the new religion had made little if any inroads into the great forested wilderness in whose heart Sheffield lay.

Maybe the wooden temple which stood on the site of today's Cathedral of St Peter and St Paul was burned to the ground during the Conqueror's devastation of the north in 1070, in which Hallamshire suffered terrible carnage. Twenty six years later the Domesday survey listed 15 places in South Yorkshire as having a church, and although it possible some Romano-British chapels may have been founded before the arrival of the heathen Anglo-Saxons, the historian Joseph Hunter concluded "there was no

church in Saxon times in any part of what now forms the parish of Sheffield".

When the first missionaries reached this remote district over a thousand years ago they would have found a forest stretching from Barnsdale near Pontefract into the Peak and Sherwood, punctuated by clearings and small farming settlements which later became our familiar villages and towns.

The small population would have worshipped a pantheon of gods and goddesses which acted as manifestations of the forces of nature and the seasons upon which their lives depended. Their beliefs sprang from a mixture of Celtic and Germanic mythology, with the two fire festivals of Beltane (May 1) and Samhain (November 1) marking the beginning and end of the summer, the harvest being of supreme importance. There were also a number of other important dates, with the midsummer and midwinter solstices marking points in the agricultural calendar.

The earliest evidence for religion in Sheffield, other than an isolated Bronze Age cup-and-ring marked stone in Ecclesall Wood, is a stone known as the Sheffield Cross, the original of which is now in the British Museum. This "cross" was discovered at the beginning of the 19th century in a town centre cutler's workshop where it was being used as a hardening trough!

This stone was probably one part of the "Great Cross" in the parish churchyard, which was pulled down and broken up during the Reformation on the order of Queen Elizabeth I. The grey sandstone slab has been compared with examples at Bakewell and Bradbourne in Derbyshire which have been dated to the early 9th century AD. The front face shows an archer with his bow drawn, kneeling amongst vine branches and grapes. Other sides have knotwork patterns and stylised trees which are typical of carvings of the Anglo-Saxon and Danish period.

Depictions of archers are found on other cross fragments, and the figure may represent "Aegil the Archer" of Anglo-Saxon literature and the Volund Saga, the legend of a symbolic contest between good and evil which is alluded to in the epic poem *Beowulf*. It is interesting that we find this motif in the same town where the great archer and outlaw Robin Hood is said to have been born!

Secrets of the Lady Chapel

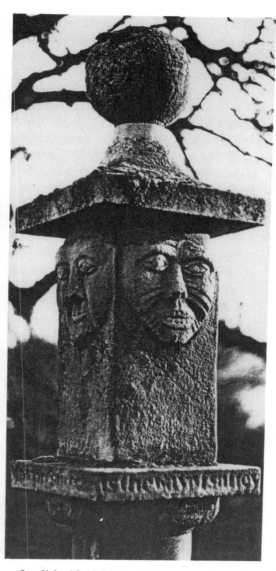

Sundial with 'Celtic head', Thorpe Salvin parish church, Rotherham. This was shaped by a local mason in the 1820s (Photo: author)

Before the first wooden and stone churches were built, itinerant missionaries and Celtic monks preached the gospel to the pagans from the base of stone crosses which may have been megaliths or standing stones, Christianised and "purified from demons" for the use of the new religion. Most survive only in place-names like Parson Cross and Banner Cross, but the Sheffield Cross probably marked the site of the pagan temple where William de Lovetot built the first Parish Church in Sheffield around the year 1100. Some of the stones from the early building are now found in the walls of the Chancel and Sanctuary of the Cathedral.

That early church was destroyed during the Baron's War in 1266, and was replaced

by another building dedicated by Wickwan, Archbishop of York. This church grew in size under the patronage of the wealthy Earls of Shrewsbury, Lords of Sheffield manor during the Tudor period. They built their own chapel in the southeast corner of the building as a family tomb, a sanctuary at a time when the monasteries were being despoiled. The Cathedral we see today is the end result of many redesigns and rebuildings, stretching from Georgian times until the addition of a controversial modern extension in the 1960s, but the majority of it dates from the 15th century.

Sheffield Cathedral is not regarded as the most ornate of its kind in the country, and was only elevated from the status of a Parish Church in 1914. To most Sheffielders, the Cathedral is not an obvious tourist attraction, it is just one of those buildings that "has always been there", but these stones hide an unbroken heritage as fascinating as anything Kelham Island or Abbeydale Industrial Hamlet can offer. For inside are symbols which tell us much about what the people of Sheffield believed about their world and the deities which created it before the arrival of modern "civilisation."

It may seem strange to look for evidence of pagan beliefs in the heart of Sheffield's Cathedral. But for those with eyes to see, one special part of the building speaks loud and clear, showing how two belief systems met, merged and lived happily together side by side at an isolated parish church in medieval England.

To really feel the magic of South Yorkshire's mysterious past go to the Lady Chapel inside Sheffield Cathedral. Many people have sensed a "presence" or "power" in this part of the ancient building, from which mysterious underground tunnels are said to run to Sheffield Castle and across Fargate. Cleaning ladies have seen the ghost of a lady, perhaps Mary Queen of Scots, hovering around the Shrewsbury tombs and others have felt "strong energy pulses" while meditating here. Imagination? A trick of the light?

To reach the heart of the mystery, first ignore the "official" guide which will tell you about the stone tablets, the brass plaques and the vast tombs of the wealthy aristocracy. Stand in the centre of the Chapel, look towards the altar and the stained glass window. The ornate tomb of the Sixth Earl of Shrewsbury,

Mary Queen of Scots gaoler, is against the wall on your right. You are facing east, the direction from which the sun rises on Midsummer day, June 21, the direction on which the Lady Chapel is orientated.

Turn your eyes upwards and there, facing you in the centre of the principal beam holding up the wooden roof is a fine carved representation of the Mother Goddess – the earliest of mankind's religious symbols. The Goddess represents Mother Earth, from whom all life was believed to spring; she appears in the earliest prehistoric depictions of creation, and her image was carved in stone as far back as the Old Stone Age when man was still a hunter-gatherer.

In this form the Mother appears as a stylised Sheela-na-gig, a Celtic name used in Ireland to describe grotesque carvings depicting the lewd figure of a woman displaying her sexual organs. Here, her legs are splayed and the roots of a tree are growing from the source of life, its leaves twisting and curling behind the roof beam she sits upon. The meaning of this carving has been lost on congregations for centuries, for to an inquisitive visitor today, the guide will say they always believed it was a depiction of "a medieval acrobat"!

Above this carving is a Christian symbol of the resurrection (the only one among all the roof carvings in the Lady Chapel). This is Agnus Dei, the lamb of God alongside a flag, a symbol of St John the Baptist whose festival was Midsummer Day, the ancient pagan festival on whose morning sunrise the Lady Chapel itself was orientated.

Here in Sheffield Cathedral, the Mother, the central focus of the Lady Chapel, is surrounded by what can only be described as an incredible suite of carvings, all of them dating from the mid-15th century, and all of them recently embossed in gold paint without which they would be invisible to the eye. These are not just fanciful creations or dabblings of an imaginative medieval mason – this suite of carvings had to be planned, paid for, and approved by a medieval priest and his congregation to whom these symbols had a real meaning and significance lost in the 20th century.

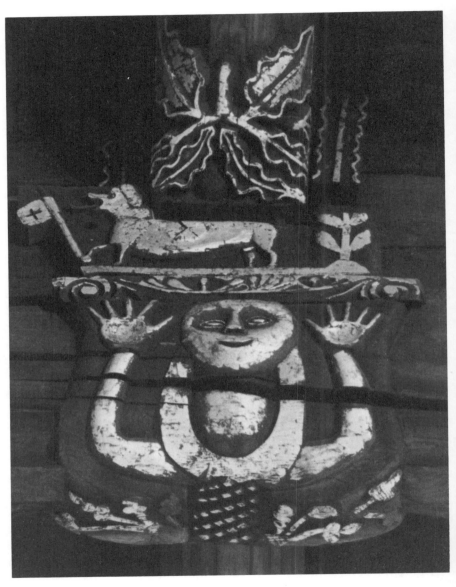

*Woodcarving of the Mother Goddess on a roof boss in Lady Chapel, Sheffield Cathedral.
This is the focus of a impressive suite of roof carvings depicting pre-Christian deities.
(Photo: Joe Sheehan)*

Moving on, behind the Mother, at the very apex of the great stained glass window above the altar is a carved boss depicting the Tree of Life spewing from the chin of a bearded face which hangs upside down, mouth open. Here we have the spirit of vegetation, the Jack-in-the-Green or trickster who turns up in the 14th century poem *Sir Gawain and the Green Knight*, a variant of whose story (composed by an unknown Peak District author) was probably familiar to the people who carved his image here.

It is the image of the tree or forest which is everywhere in this roof full of pagan imagery, for there are no less than seven carved roof bosses depicting the Green Man, geometrically arranged and all staring inwards. It seems that the medieval masons wished to bring into the holy space depictions of the sacred forests of Sherwood, Rivelin and Barnsdale which surrounded them, and from which the fruits of life were obtained. These were in all probability the same kind of images and carved idols which had once adorned the early wooden pagan temples which missionaries found in Brigantia.

The Green Man is a primordial image of a human face with leaves and foliage pouring from his mouth and eyes, the male consort of the goddess and a pre-Christian symbol of resurrection, of new life bursting forth from the dead earth in springtime. He appears most strikingly on the second most important carving in the Lady Chapel, that of the Green Man which covers the central boss of the supporting roof beam framing the entrance arch to the Lady Chapel – directly facing his consort, the Mother.

Here the Green Man is depicted surrounded by intricately carved and stylised leaves and foliage, branches of which leap from four corners of his face. Like the Green Knight in the Gawain legend he has been decapitated, for the two crossed swords above him clearly symbolise the "beheading game" found in Celtic mythology. Above the swords is a small cherub-like face and wings depicting the soul ascending to heaven. This image is a symbol depicting the rebirth of the god of spring, the Green Man.

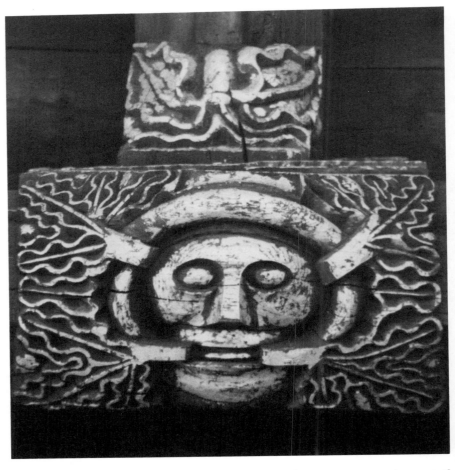

The Green Man, Lady Chapel, Sheffield Cathedral. One of seven separate carvings; out of sight and above the carving is a depiction of crossed swords which may represent the Midwinter beheading game. (Photo: Joe Sheehan)

The beheading of the Green Knight in the Gawain legend takes place at midwinter, a time of year when magical rituals were performed in pagan Britain in an attempt to bring back the life giving sun to fertilise the dead land. Leaving the Cathedral, we have only to travel six miles to the village of Grenoside, northwest

of the city centre, to find an ancient folk dance performed at midwinter, which features as its central theme a decapitation, like that depicted in the Lady Chapel.

The origins of the Grenoside Sword Dance is, like many ancient customs, lost in the mists of time, but it is only one of several examples of long-sword dances which have survived in this part of the Northern England. Before the First World War the team danced annually on Christmas Eve and Boxing Day in cottages, inns and big houses all around the hilly district. Now the men who have inherited the tradition perform on Boxing Day at Grenoside and at folk festivals throughout the year.

The unique and archaic nature of the Grenoside dance lies in the fact that the most important part is the role played by the captain, who carries a ceremonial edged sword and wears a fur hat, formerly covered by the head and skin of a rabbit (or perhaps a hare, a more magical animal). At the climax of the rhythmically complicated dance which requires a high standard of concent- ration and skill acquired through frequent practice, the final lock (a hexagram) of swords is placed around the neck of the captain who is symbolically "beheaded". The beheading sequence is found as a vital part of other ritual sword dances, and at one time in Grenoside it was known as "killing the bullock."

The dance begins with the captain's "calling on song" after which the six dancers clash their 25 inch long swords together and form a magical ring, each one holding his own sword in his right hand and the point of his neighbours in his left. Then they weave patterns, twisting beneath and jumping over the swords but never breaking the ring until the "lock", made of interlaced swords, is formed and placed around the neck of the kneeling captain. His hat is lifted from his head and he falls symbolically to the ground as if "dead". At one time he would have been restored to life by a "doctor" from among the comical mumming characters who accompany the dancers, symbolising his "rebirth".

Folklorist Cecil Sharp, who visited Grenoside in 1911, described how: "At the climax of the figure they simultaneously and vigor- ously draw their swords across his neck; there is a grinding clash

of steel, and the Lock is disentangled. So realistic is the scene in actual performance, that when I first saw it I should not have been surprised if the captain's head had toppled from his shoulders and rolled to the floor!''

Although the Sword Dance survives today as a curious and unique Boxing Day custom, there can be little doubt that at one time onlookers witnessed a symbolic re-enactment of a ritual designed to persuade the sun to return and fertilise the land at the depths of the pagan midwinter.

The human head, featuring in all these contexts, was a symbol of power of primary importance to prehistoric man, and it appears the Celtic tribes of the Iron Age held the severed head in the same kind of religious regard as Christians would the cross. From archaeological evidence we know that in early times real human skulls were kept in houses and temples and displayed as cult objects. After the arrival of Rome and Christianity heads continued to be carved in stone and wood and used as protection against evil.

A Romano-British date has been ascribed by Dr David Hey to a stone cult head with finely-carved features which was found in the rubble of an old cottage on High Street in the village of Ecclesfield, in the 1960s. It was probably carved by a local mason perhaps for use in early forms of worship at the time of the British church at Ecclesfield. Other examples have been found throughout the county in old walls and rockeries, and some were buried in topsoil no doubt in an attempt to neutralise the supernatural being they were thought to represent.

Human faces continued to be carved as gargoyles and "Green Men" in church architecture, because to the medieval peasant the natural world was alive and populated by all kinds of spirits and elemental deities. To the Christians, these nature spirits and gods became demons and devils, but despite the edicts and sermons against paganism they were still allowed inside churches and chapels throughout Britain.

The Green Man in Rotherham town centre. Top, Rotherham Parish Church and, bottom, on a Victorian building in Domine Lane (Photos: author)

Some of these carvings were made as late as the Victorian era, and served as a reminder to the congregation of the evil spirits and temptations which constantly besieged mankind. There are stylised Green Men carved on Victorian buildings in Division Street, Sheffield and Domine Lane in Rotherham and some of the finest grotesque carvings of human heads can be found on St Mary's Church in Bramall Lane, Sheffield, built as recently as the 1830s on land donated by the Duke of Norfolk!

The Head Stone or Stump John

There is historical and archaeological evidence that early man, and certainly the Celtic tribes, worshipped nature in the form of water, trees and stones at shrines in places of natural beauty which included forest clearings, springs of water and rock formations. On the Hallam Moors, just south of the A57 Manchester Road at Hollow Meadows is a remarkable natural stone which has fascinated antiquarians for over century and may have been sacred to the early settlers of the region.

It is marked on modern maps as "The Head Stone", but older sources refer to it as "Stump John" or "the Cock-Crowing Stone". The antiquarian S.O. Addy described this stone as "a natural pillar composed of three stones . . . it is said that on a certain morning in the year these stones turn round when the sun shines on them." Later, he adds: "the rock or stone is said to turn round on a certain morning in the year when the cock crows. The rock has the appearance of a stone pillar. The pillar consists of a large stone standing on top of another stone. It appears to be about 15 or 20 feet high on top of a hill and is a conspicuous object in the landscape."

The cock-crowing connection is interesting, because Addy mentions "several other large stones, or heaps of stones, in the district which are also known as 'cock-crowing stones'". His view was they were the probable sites of former pagan rites, and he mentions another stone said to turn around on a certain morning of the year on Baslow Edge. This is known as the Eagle or Witch's Stone.

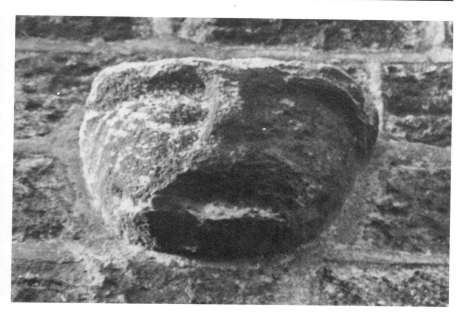

Archaic stone head in the gable end of the 12th century Porter's Lodge, Bolsterstone, near Stocksbridge. (Photo: Joe Sheehan)

The Head Stone has been the focus of local curiosity for many years. Some are of the opinion the rock formation is not of natural origin, and a writer in the *Sheffield Telegraph* in 1937 requested enlightenment as to the purpose of the stones as "one can hardly imagine them being in that position haphazard". Anyone examining the stones at close quarters will be left in no doubt as to where the name Head Stone originates, for the clear features of a human face can be seen on the topmost stone when viewed from the northwest.

When photos are taken of the stone on an August evening, with the sun shining on the west side, the shadows bring the "face" to striking prominence. It is therefore possible that the legend about the stone turning around when the sun shines upon it is the real the explanation for the appearance of the face. Earlier writers have interpreted the "cock-crowing" legend as an indication that cockerels were here sacrificed to some deity, whereas the phrase is clearly an alternative for "sun rise stone".

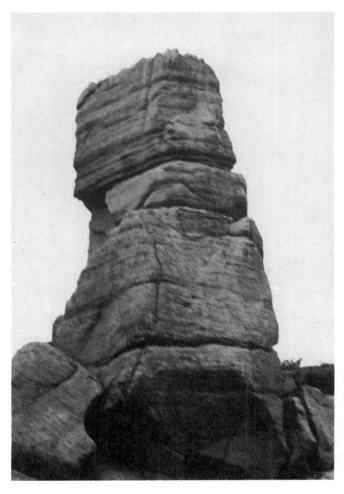

The Head Stone, high above the Hallam Moors at Hollow Meadows, west of Sheffield City Centre. (Photo: Andy Roberts)

Recent research has shown the head stone to be a marker for the sunrise at the midwinter solstice (December 21), as seen from stones nearby over the distant high point known as Whirlow, to the southwest of Sheffield (the name of a lost burial mound). The Head Stone is only one of many examples where pagan temples

have been clearly designed to act as markers for sunrise and sunsets on important festival dates. We know this took place at Sheffield Cathedral in medieval times, but to the earlier peoples rings of standing stones or monoliths acted as the stone age equivalent.

Seven Stones on Hordron Edge

In ancient times boundaries were of supreme importance. The records of medieval boundary markers in South Yorkshire are interesting because they provide evidence that many of them were ancient sacred places, standing stones, named trees and "holy" wells.

One account of a boundary was recorded on August 6, 1574, upon a meeting of 32 freeholders with the Lord of the Manor, the Earl of Shrewsbury, during which the boundaries of Hallamshire, Ecclesall and Hathersage were "gone over . . . viewed and seene."

The boundary began at the Porter Brook in Whiteley Wood near Fulwood, and ran from a tree at Hangram Lane to a stone called Stowperstocke, and from there to "the great heap of stones called Ringinglowe from which one Thomas Lee had taken and led away a greate sort of stones." From Ringinglow the boundary ran to the Burbage Brook, and then along the borders of present-day South Yorkshire, to Hurkling edge in the parish of Bradfield to a prehistoric stone circle on Hordron Edge above the present A57 road called The Seven Stones.

The account describes how the boundary between Hallam and Hathersage went "downwards to a place where certeine stones are sett upon the ends and having marks upon them called the Seavenstones; which ould and ancient men say that the name is the *mere* between my lord and the lord of Hathersedge."

The Seven Stones circle was described by archaeologist Dr John Barnatt as situated in "one of the wildest and most evocative sites in the Peak District . . . (overlooking) the Derwent Valley in the west 400 foot below, with Ladybower Reservoir at the bottom and Kinder Scout beyond." The ring of small stones (none higher than

3 feet) is often completely hidden by bracken and heather during the summer, but is well worth a visit for there is magic here.

There are in fact ten small standing stones in this beautiful and largely unspoilt prehistoric temple which is thought to be of Bronze Age date (around 3,000 BC). They stand in three main groups, and according to Barnatt one group marks the sun, which at the festivals of Imbolc (February 1) and Samhain (November 1) set behind Win Hill which the tallest stone in the circle faces, its shape mirroring that of the distinctive Derbyshire peak. The other two groups of stones mark the movements of the moon and true north. The reason for the naming of the circle is not clear, but according to the antiquarian S.O. Addy, in the folklore of Hallamshire seven is known as "the magical number".

Churches on Pagan ground

No one knows what kind of religious ceremonies took place in the stone circles which were built throughout the British Isles during the Stone and Bronze ages. We can make guesses using the archaeological evidence and folklore (which describes how they were sacrilegious dancers turned to stone) that they acted as centres for tribal gatherings where ritual dancing took place at important festivals.

At some old parish churches a custom survived where every year on the feast day of the saint parishioners would link hands and "embrace" the building. This "clypping" (embracing) custom survived at St Peter's Church at Tankersley, Barnsley, where at one time it was performed by the young people of the parish on the second Sunday in July. They would form a ring around the church and clasp their hands as buglers played on the roof above. The custom died out long ago, but was re-introduced by Canon Archibald Douglas in 1926.

The church guide ascribes the origin of the custom "in pagan rites when superstitious villagers sought refuge from wild animals by circling and embracing the church; sometimes whilst dancing, sometimes whilst singing, sometimes doing both." There is no

trace of an earlier temple or stone circle in the grounds of Tankersley church, but we know there was a chapel and priest here at the time of the Domesday Survey and it appears that the clypping took place on the same date as the "Tankersley Feast". This was a midsummer fair originally held in the churchyard, but later moved to the local pub (now the Cross Keys at Hoyland Common) when the church began to disapprove of these "wicked" activities. This appears to suggest that clypping is a survival of a midsummer circular dance performed here before the church was built.

Dr David Hey writes that "in no case is the foundation date of a medieval church within South Yorkshire known to us, and the reasons for siting a building upon a particular place are often mysterious." This lack of evidence may be explained by the fact that so many Christian churches were built upon earlier wooden pagan temples, of which no trace remains. At many South Yorkshire parish churches there is plentiful evidence of the continuity of worship from paganism to Christianity, which is most strikingly obvious where Christian structures have been built upon earlier burial mounds, and where stone heads from earlier temples have been built into their walls. One of the best examples is the hilltop church dedicated to St Nicholas at High Bradfield, which stands in a beautiful moorland setting northwest of Sheffield, only a short drive from the bustling suburb of Hillsborough.

Although Bradfield does not appear in the Domesday Survey, it once formed a chapelry of the parish of Ecclesfield in the Saxon manor of Hallamshire. Following the Norman conquest this huge and remote moorland region came into the ownership of the powerful lord Roger de Busli. Today, Bradfield is a delightful village divided into two, with Low Bradfield nestling in a green valley below where the parish church stands, connected by a steep road. High Bradfield, or Kirk Town as it was once known, is undoubtedly the oldest part of the village, with a group of strange and brooding tree-covered earthworks perched on the hillside behind the extensive graveyard.

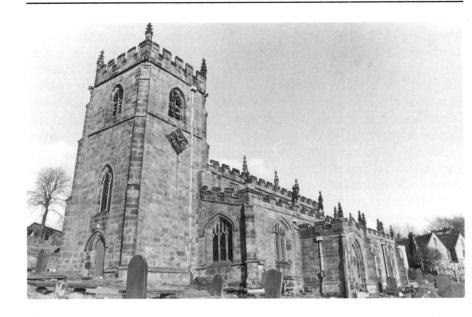

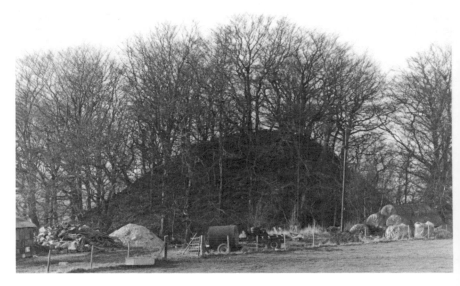

Bradfield Parish Church and the mysterious earthwork known as Bailey Hill which may have been a burial mound.(Photo: Joe Sheehan)

The church of St Nicholas dates from the 15th century, but stands on the site of a older Norman structure. Until 1868 Bradfield was a chapel of ease dependent upon Ecclesfield Priory, whose monks served as chaplains paid by the vicar of Ecclesfield Church. The strange mounds behind the church are described by historians as a Norman "motte and bailey" castle supposedly thrown up in haste after the conquest of Hallamshire as a defensive fortification.

But the evidence of tradition throws doubt upon this theory. The historian Joseph Hunter described Bailey Hill as "a Saxon camp, as fair and perfect as when first constructed, save that the keep is overgrown with bushes . . . the date of this work is now impossible to ascertain; but it is obvious that so complete a work must have been formed not in haste, or to serve any temporary purpose, but to be used as a constant military post; one of the frontier barriers, it is probable of the Kingdom of Northumbria."

S.O. Addy in his "Hall of Waltheof" (1895) said he had exa-mined Bailey Hill carefully and concluded the evidence pointed away from a defensive purpose, more that the hill was the former place of village assembly, law-giving and burial. Bailey Hill in fact consists of two artificial mounds, known as the round mound and the long mound, on a prominent high point above the undulating landscape in the valley below. The round mound is fifty feet in height and entirely surrounded by a deep trench.

"The great earthwork," he wrote. "Was originally a burial mound, and afterwards doubtless the place of the old folk moot, or village assembly, and the scene of many a religious rite . . . the appearance of Bailey Hill, as you look down upon it from the fields above, is most characteristic of a large burial mound. It is like an enormous sugar-loaf, with a flattened top, and were its sides not overgrown with stunted trees the resemblance to a pyramid would be most striking."

The name of the village, first recorded in 1337 was "Kirkton". The first stone church was built here after the Norman conquest, probably during the 12th century, and the old name probably comes from the Anglo-Saxon "cyrictun", meaning not church but cemetery. Another name for fields near the mounds in 1637 was

"Dead Man's Half Acre" . . . "Both these words," writes Addy, "are the names of a prehistoric burial place of which Bailey Hill is the most conspicuous part."

Many old churches, in particular those built before the Reformation, were built on prominent hilltops on top of or adjacent to earlier earthworks. The mounds adjoining the churchyards at Hathersage and Holmesfield, on the border region between South Yorkshire and Derbyshire (anciently Northumbria and Mercia) may also have originated in this way.

In folklore, supernatural interference with building plans is used as an explanation as to why these churches were often built in remote places away from the settlements they served. In the 6th century AD, when Pope Gregory the Great sent his missionary Augustine to England to convert the Anglo-Saxons who had taken control of the islands after the fall of Rome, he gave explicit instructions that the pagan temples he found here should not be destroyed but "purified of demons" and used for the new religion.

The opposition which the early missionaries encountered resulted in disputes about where new stone churches should be built. At Bradfield is a folktale which suggests the first choice for the site of the parish church was in Low Bradfield at the foot of the hill where a crude Anglo-Saxon cross, decorated with a sun symbol, was unearthed in 1886. The story runs that work on the church here was disturbed each night, with the building materials being moved by supernatural means to Bailey Hill on the hillside above.

This folktale indicates that High Bradfield, with its mystery mounds, was the centre of pagan worship in this remote moorland district when the first Christians arrived here during the "Dark Ages". The power of this strange and numinous place is perhaps reflected in the folktale which says there is a cache of treasure hidden deep inside Bailey Hill.

Variations of this "siting legend" are found in other parts of South Yorkshire. At Handsworth in Sheffield, the 12th century parish church of St Mary once again stands on a hilltop site, with its spire visible for miles on a clear day. A legend here describes

how the original site chosen was piece of land called Church Rein
(now Vicar Lane) at Woodhouse nearby, once the larger of the
two settlements. Every night, however, the work done during the
day was disrupted by "angels or demons", until the church was
finally built where it now stands at Handsworth. Another version
of the story tells how "three times the stones were laid ready and
three times, after the workmen had gone home, the devil removed
the stones to Handsworth, where the church was built about
1175."

Elsewhere "the devil" (the old religion) was busy, for the same
story is found at Penistone near Barnsley, where the church was
planned at the hamlet known as Snowden Hill, and at Braithwell
near Rotherham, where the original plan was to build the church
by the side of a holy well. The old beliefs about which spot was
best for a temple usually prevailed, and this explains why so
many of our early churches are built upon places sacred to earlier
peoples.

Perhaps the finest example of a church built upon a site of early
worship in South Yorkshire is to be found at the village of
Cantley, near Doncaster. Here, the little limestone church dedica-
ted to St Wilfrid dates from 1257, but stands on the site of a
building recorded by the Domesday survey which historians
believe stands upon a "Romano-British temple". Dr David Hey
noted how the building stands on a mound in an odd position
away from the village alongside a Roman road, with a peculiar
orientation 40 degrees to the north rather than due east, as was
the custom.

In 1953 when a new housing state was being built at Cantley, a
mechanical digger unearthed an enormous quantity of broken
pottery which turned out to be the remains of Roman kilns from a
long lost industrial settlement. "The mystery cannot be ade-
quately," explained Dr Hey. "But it is possible that Cantley
church was founded upon a site that had associations with earlier
forms of worship. An assumption that the church replaced a
pagan temple or burial ground associated with the pottery kilns

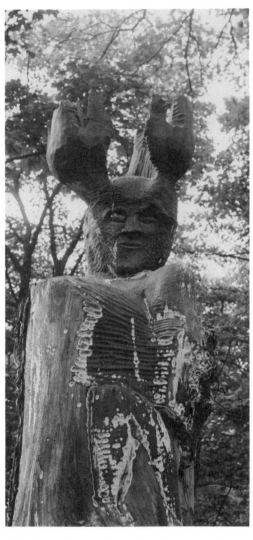

The Green Man as Herne the Hunter, carving in the evocative Waterfall Wood at Graves Park, Norton, Sheffield. The 12ft high figure was carved from the stump of a tree in the 1980s as part of a sculpture trail funded by the Henry Moore foundation. (Photo: author)

makes some sense of the strange orientation, the dedication and the choice of site."

Even during the later medieval period when abbeys and monasteries were founded, the places selected appear to have been chosen by the traditional, magical methods like divination. In Barnsley, the second largest monastery in South Yorkshire was the Cluniac priory of Monk Bretton, founded by monks from the Priory of St John at Pontefract in the 12th century. The monks, who a century later changed their allegiance to the Benedictine order, received the seven acres of land on which the abbey was founded from a local lord, Adam FitzSwein, in 1154. It was a clearing or "lound" on the banks of the River Dearne near the southern boundary of the parish. Dr Hey remarks that lound is an odd placename in this context, and may indicate this was originally a Scandinavian word meaning "sacred grove".

The largest monastic establishment in the county, Roche Abbey near Rotherham, is also set in a beautiful, secluded and numinous spot again on a boundary formed by Maltby Beck which divided the parishes of Maltby and Laughton-en-le-Morthen. The land was granted to Cistercian monks from Northumberland by the Norman lord Roger de Busli in 1147, and the monastery was dedicated to the Virgin Mary like all the abbeys of the order. But in this case the abbey took the name "Sancta Maria de Rupe" from the rocky limestone outcrop to the north of the church. Here there was a particular rock formation "on which a resemblance of the Cross could be seen", and this had become a centre of pilgrimage.

As late as the 12th century while the great abbeys and churches of the region were under construction, people were still paying homage to the old gods in the form of natural rock formations, magical wells and springs and ancient trees. They continued to place their faith in magical remedies and village wise-people whose practices would today be described as form of "white witchcraft". Indeed, in 1606 Nicholas Bown observed that peasants in the countryside knew more about the legendary hero Robin Hood than they did about Bible stories which were "as strange unto them as any news you can tell them . . . "

2

Robin of Loxley

"I have heard talk of Robin Hood,
Derry down, derry down,
And of brave Little John;
Of Fryer Tuck and Will Scarlet,
Loxley and Maid Marian."

In September, 1637, the surveyor John Harrison recorded the following entry under a record of the estates of Thomas Howard, Earl of Arundel and Lord of the Manor of Sheffield:

"Imprimis Great Haggas Croft (pasture) near Robin Hood's Bower and is invironed with Loxley Firth (forest) . . . Item, Little Haggas croft (pasture) wherein is the foundation of a house or cottage where Robin Hood was born; this piece is compassed about with Loxley Firth".

So began the local legend which says the famous outlaw Robin Hood was born at Loxley, in the parish of Bradfield, now a quiet suburb of northwest Sheffield. In the Middle Ages, the greater part of the district known as Loxley Chase was covered by a mighty forest which stretched from Barnsdale near Pontefract to Sherwood, which later myth makers chose as the setting for the popular hero's adventures.

What vague facts there are show that in the earliest ballads Robin Hood is described as an outlaw living in the forest of Barnsdale, south of present day Pontefract. His connection with Nottingham, and the stories about his companions Maid Marion and Friar Tuck, were additions of later centuries.

I do not intend here to enter the debate about when or if Robin Hood existed in reality, but to examine the traditions which connect Loxley in Sheffield with his birthplace. The traveller

Roger Dodsworth, who visited the area early in the 17th century, recorded one of the earliest folk-tales in his papers: "Robin Locksley was born in Bradfield parish in Hallamshire, wounded his stepfather to death at plough, fled into the woods, and was relieved by his mother until discovered. Then he went to Clifton-upon-Calder and became acquainted with Little John, who kept the kine, which said John is buried at Heathershead [Hathersage] in Derbyshire, where he hath a fair tombstone, with an inscription."

Another historian noted how, at the beginning of the 19th century, the remains of Little Haggas Croft (croft being a small farm adjoining a dwelling) were still to be found upon the Loxley hillside adjoining Little Matlock. The exact spot was down a lane near Normandale House, but the "foundations" recorded by John Harrison three hundred years earlier were removed in 1884 to build the present Warren House.

A photograph published in the *Sheffield Telegraph* in November 1937 purported to show an oak beam said to be part of the cottage described by Harrison as "where Robin Hood was born", and in 1887 it was said a forestry expert had declared it had been grown in the forest nearby and was a thousand years old. The gates for the rafters had been rudely fashioned by an unknown tool, and there were the remains of bracken with which the roof had been thatched.

But S.O. Addy, writing in the following year, was unimpressed. "Many places have claimed to be the birthplace of this hero of the woods as many cities have claimed to be the birthplace of Homer," he wrote. "I confess to some surprise at seeing such a statement in so formal a document as a survey of land . . . it cannot have been an invention of the surveyor himself so he must have heard it from the lips of men who then occupied that secluded village, and probably the belief had long been current that some man of prowess had once inhabited these wilds, had stolen the king's deer, and accomplished feats of bravery and generosity.

"But I remember, when riding on a coach in Scotland hearing

the coachman as we passed by a ruined cottage say: 'Gentleman, this is one of the houses where Rob Roy was born'. And here we have learnt on a much earlier authority that Bradfield was one of the places where Robin Hood was born."

One of the most interesting place-names in Loxley is Robin Hood's Bower; in Harrison's Survey of 1637 Great Haggas Croft was said to be "near Robin Hood's Bower", also mentioned nearby are Bower Wood and Bower Field. In placing Robin Hood in a mythological context, it is worth noting that "robin", "robert" and "hob" are common among the field-names of the district. In Harrison's Survey the word "wood" is interchangeable with "hood", and therefore Robin Hood becomes "Robin of the Wood", and it is clear he is really a metaphor for a spirit of vegetation, for Robin himself is often represented in folk tradition as "The Green Man", as depicted on many pub signs.

S.O. Addy dismissed the contradictory historical "evidence" for Robin Hood as far back as 1895. In "The Hall of Waltheof" he described Great Haggas Croft as "less than an acre in the heart of the forest. Perhaps some wood sprite or sylvan god was once worshipped there. When Alice Duke, a witch, was examined in 1664 she is reported to have said that "when the Devil doth anything for her she calls for him by the name of Robin, upon which he appears" . . . we may be sure that Haggas Croft was once the abode of a sorceress or witch. The very foundations of the witch's house were left, and the name Haggas – Old English "haegesse", a witch – can hardly be mistaken."

In a later essay Addy continued his arguments. "The point of interest in Harrison's Survey lies not in the statement that Robin Hood was born in Loxley, but in the evident long continuation there of a ceremony associated with his name. I say the long continuance, because the mention of places such as Bower Wood and Bower Field in connection with Robin Hood's Bower shows that such a fabric had long existed there. A new bower may have been erected every summer, but here at any rate we seem to have a permanent site."

From the old churchwarden's accounts it is clear that "Robin

Hood's Bower" was in fact a booth or tent made for the reception of Robin, the May King and this companions during the annual May Games. The bower was usually set up in the churchyard, but at Loxley there was no church, so this ceremony took place in the greenwood. It also took place at the nearby parish church in Ecclesfield, for in Thomas Winder's "Old Ecclesfield Diary" (1921) it is recorded under the year 1792 how a Scots bagpipe player died in "they Summer Hall", which appears to have been a structure of a more permanent kind than a tent. The games associated with Robin Hood were of considerable antiquity, and were celebrated on the first and succeeding days of May to the eighth, the period of the great pagan fire festival of Beltane – the bringing in of the summer.

Robin Hood's Cave, Stanage Edge on the western boundary of South Yorkshire and Derbyshire. (Photo: Sheffield City Libraries)

The theory that Robin Hood was a mythological figure rather than a real man may disappoint many who, in a book on the legends of

South Yorkshire, may expect me to give credence to the story that he really was born here. It is certainly possible that a Robin Hood was born in Loxley, but there appear to be literally dozens of other Robin Hoods scattered throughout history both in time and space, all of them equal contenders for the title. But what we can be certain about is that many of those bearing his name during the Middle Ages – such as Thomas Robynhood recorded in Wakefield in 1388 – got their names from having played the part of the outlaw in the May Games.

S.O. Addy and, later, Lewis Spence compared the character of Robin Hood with ancient gods and heroes from Norse and Celtic mythology. Addy notes how: "Robin Hood can be compared with Odin [known as 'the masked or hooded one'], on account of him travelling in disguise. The name Scathelocke, afterwards changed to Scarlett, one of Robin's companions, has a heathenish sound. It makes us think of Loki the evil giant god of the North, and of Scathi who, according to the Ynglinga Saga, was Odin's wife."

He regarded the legend of Little John at Hathersage as yet another belief about a genius loci or "spirit of the place". "The Roman road between Stanage Pole and Hathersage is known as the Giant's Causey," he wrote. "Now if that were so, it may be that the termination occurs in Hathersage, which we may divide as "Hather's Way". "Hodr" was a mythical being or giant who, according to the old legends or popular tales of the neighbour-hood, made a great causey or paved way. Little John, the mythical companion of Robin Hood, is said to have been buried at Hather-sage, and the exact place of his burial is still pointed out in the churchyard . . ."

The belief in a giant buried in the churchyard at Hathersage is consistent with legends from Calderdale in West Yorkshire, where Robin Hood is depicted as a giant, or having supernatural powers, tossing stones and boulders across the valley in a way which suggests he was originally a pagan deity.

Seven miles from Hathersage Robin Hood place-names are very common in the parish of Bradfield where Robin is said to have been born and belief about him is reflected in the Loxley land-scape. In 1741, according to the historian John Wilson, there was

"a remarkable round row of stones called by the vulgar Robin Hood's Ring, but probably it was a place walled round for the shooting of deer, of which there were many formerly kept here . . . (also) at the top of Loxley Common is a little wood called Barrwood, in which they pretend to show the house wherein Robin Hood was born, and call a well near it Robin Hood's Well."

Although no trace now exists of the Ring (a stone circle?), his Well remained in existence up until the 19th century near the River Loxley at Little Matlock, where according to Hunter the spring was "of fine clear water, rising near the bed of the river, called Robin Hood's Well since time immemorial." Many other wells and springs, named after the famous outlaw, exist within the county boundary. For example, in the parish of Ecclesfield, on the grassy banks of a stream in Low Hall Wood, is a natural spring marked on the ordnance maps as "Robin Hood Well".

A better-known well, once covered by an 18th century folly designed by Vanburgh (now moved from its original location) is situated by the side of the A1 road in the forest of Barnsdale, at Skelbrooke north of Doncaster. This spring of "clear water", flowing on the north side of a stream known as the Skell, was described as "the stone of Robin Hood" in a charter of 1422, on the meeting point of three parishes. Nearby was the Bishop's Tree, the site of a encounter between Robin and the Bishop of Durham.

Hunter, writing in the early 19th century, noted how the spring was situated on the line of the Roman road from Lincoln to York "and it is manifest from the number of Roman coins which have been discovered in its immediate vicinity, together with fibulae and other small relics of that people, that there was some kind of settlement at that spot."

His guess was accurate – in the 1960s aerial photography discovered the remains of a Roman fort to the east of Robin Hood's Well. Archaeologists believe the fort may be contemporary with that at Danum (Doncaster), and it is possible the original well here may have been a sacred spring where offerings were cast by soldiers and native Celts.

Yet more Robin Hood Wells exist on Derwent Edge on the Bradfield Moors, on a piece of marshy land known as "Robin

Hood's Moss". Not far away, on Hurkling Edge, two and a half miles from Bradfield is another Robin Hood's Well, a place-name recorded by rambler G.H.B. Ward in 1958. Describing this spring, Rob Wilson writes: "A few feet away is a solitary hawthorn tree and the only tree to be found in the entire area on this part of the open moor. This may be of significance as hawthorns have associations with sacred springs, and Robin Hood's Well may have been regarded as such from a very early time."

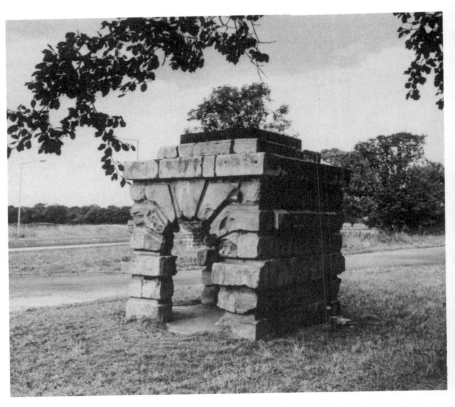

Robin Hood's Well, beside the A1 at Skelbrooke, near Doncaster. The stone well cover, designed by Vanburgh, has been moved from the site of a spring described in a 15th-century document as "the stone of Robin Hood". (Photo: Copyright Sheffield Newspapers)

The Green Man

It is Robin's connection with trees and the greenwood which suggests he was originally a deity associated with springtime and the growth of vegetation. His tomb at Kirklees Priory near Halifax was described in the 18th century as a great monolith or standing stone, surrounded by a grove of sacred trees. People went there on pilgrimages, and miracles were worked, as in other centres of pagan worship.

Robin as a personification of nature is reflected in folklore which describes how he lived or hid in certain trees. The famous Major Oak in Sherwood Forest is probably the best known of Robin's hiding places, but a tree known as Robin Hood's Oak stood for many years on Wharncliffe Crags, near the hunting lodge, at over 300ft above sea level. There was a legend here that Robin Hood once hid inside the tree, described in 1935 as one of the last remaining "monarchs" of the forest which once covered the region.

Ancient and venerated trees, standing stones and sacred springs, these are the places haunted by Robin, they are also the natural centres of the Old Religion whose influence lingered into the Christian period. The association of natural landscape features with the legendary outlaw led ley-hunter Alfred Watkins to the conclusion, in 1925, that "the number of Robin Hood's Butts and hills and earthworks, absolutely disprove the idea that the original name was an outlaw of the Middle Ages. The name is assuredly far earlier."

Robin Hood as the King of the May, or sacrificial king who reigns for an allotted period before he is sacrificed survives today in a symbolic form at one isolated village hidden in the hills of the Peak District, not very far from Loxley. The well-known Castleton Garland Day is held every year on May 29 (traditionally Oak Apple Day) in the High Peak village. Here a "Garland King" or Green Man is covered by a beehive or pyramid-shaped garland of flowers and greenery collected from the parish and then escorted on horseback through the village streets followed by a band and

at one time Morris dancers and a May Queen. Later the King's garland is hoisted to the top of the church tower and left there for a week.

It is possible the Castleton tradition was originally of pagan origin, and it may give us a glimpse of the rituals which once accompanied the May Games at Loxley and elsewhere. The pagan undertones of the Robin Hood tales have been noted by many writers; they appealed to the deep-rooted beliefs of the peasantry, and attacked the upper clergy and their Norman overlords.

The undercurrent of belief in the nature spirit which is Robin, the Green Man, manifests itself in many of the parish churches which contain images of the god, carved with furious intensity, often with leaves and greenery spreading from his mouth, eyes, ears and nostrils. Some of these Green Men may be depictions of those who on May Day, like the King at Castleton, dressed in a garland of flowers to represent the Jack-in-the-Green. The *Oxford English Dictionary* defines this as: "a man or boy inclosed in a wooden or wicker pyramidal framework covered with leaves, in the May Day sports of chimney sweepers."

In the nave of All Saints Church, Silkstone, near Barnsley, are a number of strangely-carved roof-bosses dating from the 15th century depicting human heads and other magical symbols. There are two foliate heads, and the most striking carving was described by Kathleen Basford as "a nightmarish Green Man with staring eyes and a screaming mouth. Leaves spurt up from the tear glands as well as out of the mouth, and one might think that they sting him like nettles."

Carvings of the Green Man are widespread in South Yorkshire, from the marvellous imagery in the Lady Chapel at Sheffield Cathedral, to the capitals in Rotherham Parish Church and roof bosses at High Bradfield, Ecclesfield, Treeton and Silkstone. Many of these carvings date from the 15th century, when the symbol appears to have become very popular among the masons who built parish churches and cathedrals across the county.

The church was an appropriate place for carvings of the Green Man, for the clothes and equipment used by the actors in the May

Games were often stored there and Robin Hood's Bower itself was often built in the churchyard. It is hardly surprising that the masons who built the Christian centre of worship chose to incorporate the face of an earlier deity into the stone fabric of the new god.

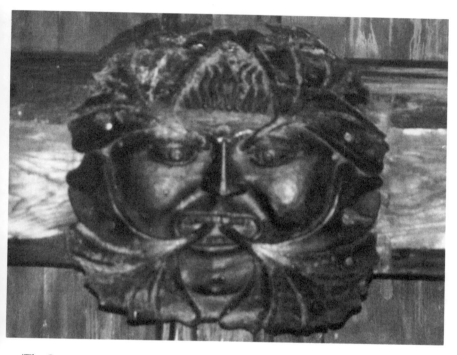

'The Green Man' depicted in a roof boss in Silkstone Church near Barnsley. (Photo: Andy Roberts)

Place-names survive in South Yorkshire which give clues to the places where May Day ceremonies were once held. In Barnsley "May Day Green" formed the southern end of the small town until the 19th century, a name which dates back to the Middle Ages. In 1249, after the manor had been granted to the monks of the Cluniac priory of St John at Pontefract, a charter was obtained for a weekly market and annual fair which was traditionally

associated with May Day, the games performed at the bottom of the hill in the town. At nearby Cawthorne, the inhabitants were censured by the church authorities in 1596 for taking "towers and garlandes and other formes of thinges covered with flowers" into the parish church on the first of May.

The popularity and longevity of the May Games is clear in Sheffield, where the money made was once the chief means of support for three chaplains of the parish church. The money was made by brewing beer in the church (now the Cathedral) and sold at inflated prices. The object of the Summer Game, or the game of Robin Hood, was to "bring the summer in". The games survived until the beginning of the 19th century in the "Irish quarter" of Sheffield, now Snig Hill. A writer in *Hones's Everyday Book* of 1827 gave an account of what was then a recently-defunct ceremony performed every year at one time on May 29, the same day as the Castleton Garland, at Scotland Street and nearby:

"On the eve of the feast . . . parties of the inhabitants repair into the neighbouring country; whence, chiefly, however from Walkley Bank, they bring home, at the dead of night, or morning's earliest dawn, from sixteen to twenty well-sized birch trees besides a profusion of branches. The trees they instantly plant in two rows; one on each side of the street. With branches they decorate the doors and windows of the houses, the sign-boards the drinking shops and so on. By five or six in the morning Scotland Street, which is not very wide, has the appearance of a grove. And soon, from ropes stretched across it, superb garlands delight the eyes and dance of the heads of the feast folk. These garlands are composed of hoops, wreathed round with foliage and flowers, fluttering with variously coloured ribands. Before the door of the principle ale-house, the largest tree is always planted. The sign of this house is, if my memory does not deceive me, the Royal Oak."

This "Feast", and there were many others formerly held in Sheffield, like the Crookes Feast on May 1, lasted a week and was kept up not only in Scotland Street, but in other adjacent streets. The trees planted on each side of the street were young birch trees, brought from Upperthorpe and Walkley. During the celeb-

rations there was always "much dancing and drinking and other merry-making" during which the people "drank up all the ale in the district."

As time passed both the Castleton and Scotland Street "Summer Games" became confused with the restoration of King Charles II to the throne in 1660, but they originated as archaic ceremonies which had been observed in the district for many generations. The symbolism of the beheaded king, with his son hiding in an oak tree would not have been lost on the common people at a time when all forms of "idolatry" were being suppressed by the Puritans during the 17th century. But the restoration of the monarchy in 1660 provided an excuse to restart a custom which was dear to the hearts of the people.

The deep seated feelings surrounding the figure of Robin Hood and the May Games is made clear by Bishop Latimer, who in a sermon preached before King Edward VI complained about Robin Hood's Day "kept by country people in memory of him". He said: "I came once myself to a place riding a journey from London, and sent word overnight into the town that I would preach there in the morning because it was a holy day, and I took my horses and my company and went thither; when I came there the church door was fast locked. I tarried there half and hour and more; at last the key was found, and one of the parish came to me and says: 'This is a busy day with us, we cannot hear you; this is Robin Hoode's Day, the parish is gone abroad to gather for Robin Hoode."

Ironically, in 1554 when the hapless bishop was executed in a public burning, one of the barbarous onlookers was heard to remark that it was unfortunate "it had not taken place earlier in the season as then it might have saved the crops" !

3

Mysteries of
Wells and Water

As far back as the Bronze Age, our ancestors appear to have believed that rivers, springs and wells were the dwelling places of gods and supernatural power. Water itself was the prime source of life, and the movement and early settlement of early man was dictated by the availability of water sources.

Man's dependence on water gave it a mystical significance and to the Celtic peoples certain springs and rivers were sacred places of pilgrimage and sacrifice. Springs and wells were venerated, and offerings of pins, flowers and greenery were made to them at certain times of year, most important of which was May Day, the beginning of summer and originally the pagan Celtic festival of Beltane, when the powers of the water were at their most potent. In South Yorkshire, ancient wells, springs and spas are a forgotten part of our heritage, and many which were once used by people in search of a cure for dozens of ailments have been lost, vandalised or polluted since the industrial revolution.

Although well-dressing has had a recent revival in some villages in South Yorkshire and Derbyshire, there is evidence of water worship in Peakland as far back as the Iron Age. The sacred spring of the Celtic goddess Anu at Buxton was developed by the Romans as Aquae Arnemetia, and in nearby Poole's Cavern archaeologists have found evidence of a shrine to water gods, where both native Britons and Romans left offerings. Water worship has survived in the form of the annual well dressings which continue to be held under the auspices of the church to give thanks for the gift of water.

A desire to resurrect well-dressing traditions led a group of

dedicated members of the Penistone and District Society to clean up and restore a 15th century well in the town centre in the early 1990s. St Mary's Well off Church Street was used by local people for hundreds of years as the main source of fresh spring water until the arrival of taps and reservoirs, when the well and adjoining water trough fell into disrepair and became an eyesore.

Work on the restoration of the well was completed in February 1993, when the waters were blessed in a special ceremony. Councillor Brenda Hinchcliff said she came up with the idea after visiting well dressings in the Peak District and said if Penistone was to introduce its own ceremony "it would be a wonderful event which would attract a great deal of interest and ensure the refurbished well remains an important part of community life." These are fine words indeed, and the work of Penistone and District Society deserves praise at a time when so much of the county's ancient heritage is under threat from development and "progress".

Spaw Wells

Perhaps the most ancient and mysterious of the few surviving venerated springs in the county is Gunthwaite Spa, also near Penistone, which has unfortunately suffered not so much from development as from misguided "improvement". Gunthwaite itself is a old Scandinavian name, and the remote and little known sulphurous spring here was never christianised like St Mary's Well and others. It was never given the protection of a saint and no priest ever preached at this remote spot, but the spring continued to function as a meeting place and no doubt a centre for offerings many years after the arrival of Christianity in South Yorkshire.

John Dransfield, in his *History of Penistone* wrote: "The first Sunday in May has been immemorially held to be the opening day of the Spa, and bands of music from various places – as many as seven have been known to be there at once – and stalls for refreshments together with the numerous crowds who attended, made the occasion like a fair, and at last gave rise to such

trespassing and unseemly conduct, that some thirty or forty years ago an end was put to such gatherings."

Until recently a venerable ash tree grew here with its roots entwined in the spot where the spring water surfaced, an old millstone framing the water source itself. That was before Barnsley Council decided to "improve" the area, sawing down the tree and providing the spa with a brick surround and sign warning pilgrims to always boil the spring water before drinking it. A reporter from the *Sheffield Telegraph* who visited the spot early in 1904 observed that the waters had then been redirected through a rubble wall via a rusty iron pipe whereas "formerly the water came out of the ground by the little stream among the rushes and rough undergrowth bordering the road . . . an old gentleman did not approve of such changes, and did not think the water so good now it came through a pipe."

The writer was visiting Gunthwaite Spa to observe the annual gathering early in May that year, and his account is of great interest, for it tells of the great regard which people from all round the district had for the powers of the waters. "It has been in existence as long as the memory of man can travel back, and has been there as long before the mystery and wonder of the district," he wrote. "It has a spring of water in which the people of the district have wonderful faith. They look upon it as a sort of cure-all; but if you are to be cured you must drink of the waters on one special day in the year – the first Sunday in May. On other days the spring is just water. But on that day it becomes miraculously charged with all kinds of powers and properties, and people flock to it from far and near."

He went on to describe how people brought cups and bottles with them to drink from the waters, which one present described as tasting like "rotten eggs", no doubt because of its sulphur content. Dransfield records how the water there had been successfully used as a cure "for scurvy, inflammations, liver complaints and other diseases." Indeed, researcher Rob Wilson notes how as recently as 1982 a national newspaper reported how a woman crippled with a spinal disease had her pain relieved after taking the waters of the spa over a two-week period.

Local people still visit Gunthwaite Spa on the first Sunday in May, and are entertained by a brass band, but today most visitors go there for a picnic in pleasant surroundings although the magic of this sacred spring has not been entirely forgotten. The name of the deity which presided over the waters at Gunthwaite has not survived, and elsewhere in the country the guardian spirits of the pagan springs were often replaced by Christian saints, becoming "holy wells" in the process.

At one time "holy wells" and mineral spas existed in every district of the county and were daily resorted to by people before the invention of the tap water supplies which we all take for granted today. Well water was said to cure a range of common ailments, ranging from warts, asthma and sore eyes to lameness and stomach disorders. From the mid 16th century the therapeutic use of natural mineral spa waters became very popular in England, and spa-towns such as Buxton and Harrogate remained centres of pilgrimage until the beginning of this century.

One of the best known medicinal spas in South Yorkshire was that at Spa Farm, Treeton, in Rotherham. The house here was bought by Squire George Westby of Guilthwaite Hall in the 18th century and he found a spring of clear water on the estate and erected a building above it. Soon people were travelling to the district from miles around to use the spring water as treatment for a variety of illnesses.

In 1734 Dr Thomas Short M.D. of Sheffield, in a book on mineral springs and spas in Derbyshire, Lincolnshire and Yorkshire, wrote: "The water has done many great cures in indigestion, belching and acrimony of the humours of the body . . . labourers who lost their limbs, by lying out in the night dews, have found relief here." One of the most extreme cures was that of stonemason William Mercer who is said to have had his head of hair restored by the "magical" waters of the spring.

After the death of George Westby Treeton Spa fell into disuse, but the Hirst family who still farm the land obtain their water from the spring, which rises from the ground at the side of Bolehill in the former mining village. A similar spa well whose

water had a "magical" reputation for curing ailments is remembered today only in the name Spa Lane at the village of Woodhouse, several miles away in Sheffield.

Spas were also found at Fulwood, Broomhall and Pond Well Hill (now Pond Street) in Sheffield and at Askern in Doncaster, but only one of those mentioned by Dr Short in 1734, "a chalybeate on Burleigh Moor" – Birley Spa at Hackenthorpe in Sheffield – survives today.

Birley Spa has been described as one of Sheffield's "best kept secrets" and the mineral waters hidden in this leafy glen in the Shirebrook Valley may have been used for nearly 10,000 years. Mesolithic (middle Stone Age, circa 7,000 BC) implements have been found in the vicinity, and there has always been a strong local legend that a "Roman bath" existed here. The best preserved part of the spa today is the marble-lined cold plunging bath, an oval pool of dark water six feet deep which is fed by a spring.

The bath was built by Earl Manvers of Thoresby Hall, and at one time the spa was so popular it almost rivalled those at Buxton and Bath. Buses ran twice daily from the city centre, taking visitors seeking cures in the hot and cold baths. A writer of that time said the spa was situated "in a sylvan and rural glen, entirely surrounded by romantic hills, tastefully laid out and planted . . . " also in the grounds was an ancient tree "an oak said to be over a thousand years old, its gnarled branches giving configurations of various animal heads."

The bath house, a squat building which dates from 1843, was saved from demolition in 1960, by which time Birley Spa had fallen into dereliction and was surrounded by new housing estates. Local opinion saved the spa, and in 1967 it became a Grade II listed building. Since that time Sheffield City Council's Countryside Management Unit have drawn up ambitious plans to open the Spa House as a visitor's centre and base for educational walks in the surrounding woodland. In 1990 a group of dedicated local people brought the idea to reality, working hard for many months to restore the spa house. The restored spa was reopened in the spring of 1993, on its 150th anniversary, to coincide with Environment Week and the city's centenary celebrations.

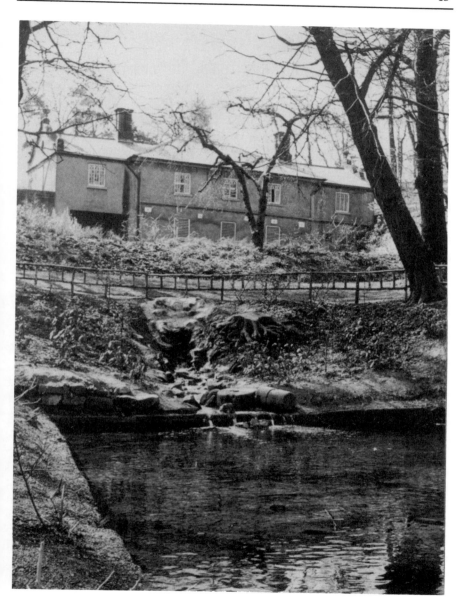

Birley Spa, Hackenthorpe. (Photo: Copyright R. Brightman, Sheffield City Libraries)

Holy Wells

Birley Spa has been fortunate. Today, the majority of the holy wells, springs and spas in South Yorkshire have been lost or destroyed. One of the few which does survive is St James' Well at the hamlet of Midhopestones, near Stocksbridge, which is now the centre-piece of a well-blessing ceremony every summer, revived by Bradfield Parish Council, who have restored it to its present condition.

The plaque which accompanies the well carries a quotation from historian Joseph Kenworthy which reads: "St James' Well at nether Midhope in the precincts of the manorial homestead of Midhope-in-Waldershelf, may have been held in superstitious reverence long before Anglo-Saxon, Dane or Norman came on the scene."

Indeed, sacred wells and springs are often found at places of prehistoric sanctity, including mounds and standing stones. Archaeologists have found that the sites of many of the more ancient Christian churches were built above springs and underground water sources on the sites of pagan temples which they covered. The best examples are the springs in the crypts at York Minster and Glasgow Cathedral, and locally there is one below the church of St John's in the parish of Laughton-en-le-Morthen, near Rotherham.

Dr David Hey has noted how the old and disused church at Throapham, dedicated to St John the Baptist is "sited curiously within a small loop of its own boundary in the middle of St John's Field, one of the three open fields of the village of Laughton." A clue to the mysterious position of the church, only a short distance from the larger Saxon church and mound at Laughton, was provided by the traveller Roger Dodsworth, who visited the church in 1631. He noted how at that time pilgrims visited the church in large numbers to attend a Midsummer fair.

The puzzle becomes clearer when the church itself is examined, for beneath the chancel door of the building are the remains of a spring which Dr Hey says "may have been a revered site whose

heathen associations had been replaced by a dedication to the Baptist," he continues: "The bonding on the south chancel wall shows that the building settled a few inches during construction; is it too fanciful to suppose this was because the church was built over a spring or well?"

At High Bradfield in Sheffield the sacred mound of Bailey Hill also had a venerated spring within yards of its boundary. The Rev Gatty in *A Life at One Living* described how "a few feet down the embankment sloping to the west is a spring of water, the brightness and coldness of which surpasses any in the district. It flows through a fissure in the solid rock and within the memory man has never been known to fail. There was a notion prevalent in the district that the water of the Bailey Well has curative properties and people go to drink it, but I have never found which particular diseases it effects."

Wells named after Christian saints are probably of archaic origin, but sadly in many cases today the only evidence remaining are street and road names, some very familiar like Wellgate in Rotherham and Twentywell Lane at Bradway in Sheffield (which takes its name from the lost "St Quentin's Well"). Many of the saints who have given their names to holy wells are very obscure, and it is probable that some of them really refer to the pagan deities they replaced.

The most popular patron of holy wells in the North of England was St Helen, and her name is invoked frequently at springs in South Yorkshire, some of them very ancient. In Sheffield there was St Helen's Lane at Walkley, Ellen's Cliff and Helliwell at Deepcar and in Rotherham was St Helen's Field at Thorpe Hesley and St Ellen's Field at Wentworth.

In some places chapels dedicated to St Helen were built during the Middle Ages to accommodate pilgrims visiting springs dedicated to her name. The ruins of one survive in St Ellen's Field, one of three medieval open fields of the village of Barnburgh, near Doncaster. The medicinal spring here is now dry and filled in, and the chapel ruins are believed to be of Norman date. A similar curative well dedicated to St Helen formerly existed at Athersley,

Barnsley, with an adjoining chapel where Dodsworth noted "whither they us'd to come on Pilgrimage."

St Helen, originally Elen a Celtic goddess, entered Christian mythology as the name of the mother of the Roman Emperor Constantine, who is credited as the finder of the True Cross. The old church at Treeton, near Rotherham, dedicated to St Helen, is one of the few in this region which appear in the Domesday book, and its proximity to the Roman road at Templeborough suggests it may stand on the site of a temple dedicated to this Celtic goddess.

At Crookes in Sheffield is St Anthony's Well and St Anthony's Hill, the site of another spring, this time dedicated to a mysterious male deity. In 1895 it was noted how "forty years ago the inhabitants of Crookes believed that the waters of St Anthony's Well would cure various diseases. The supply of water never fails in the driest summer". The reputation of the waters may date back very far indeed, for it was very near the site of this magical spring, at Cocked Hat Lane on the Bole Hills, that two Bronze Age burial urns were found in the spring of 1887. One of them contained cremated human bones, a damaged bronze knife and small cup. The remains are now kept at Weston Park Museum.

Water Deities

Some springs and wells which escaped christianisation, sometimes because of their isolation, are quite clearly named after pagan divinities. Friday Well, at Marr near Doncaster ("Frigedaeg Wella" in 1847) is the well of the Norse goddess Freya. St Anne's Well at Redmires in Sheffield is probably from name of the mother goddess known to the Irish as Anu or Danu, the same goddess (Arnemetia) which presided over the sacred springs at Buxton. The name is also found at the lost Anna's Well in Smithy Wood, Woodseats.

A spring known as Helrin or Olrin Well at Bradway, mentioned in a document of 1280, may have got its name from the Norse term for a wise woman or crone; therefore the name means well

of the prophetess or sorceress. It is the same as that of a well at
Dore called Sparken Well or Sparken Spring. "Children living at
Dore," wrote S.O. Addy, "were afraid to fetch water from a well
called Sparken Well, because they said, it was haunted by a
spirit".

In medieval Sheffield there existed a chapel dedicated to Our
Lady on the old bridge which crossed the River Don between
Waingate and the Wicker. The Norman structure built by the
Norman baron William de Lovetot near Sheffield Castle was
rebuilt in 1485 but retained the name Lady's Bridge. The lady
referred to here is once again the Mother Goddess who in her
triple form presided over sacred waters and to whom sacrificial
offerings may at one time have been offered in return for a good
weather and a plentiful harvest. The River Don, the most impor-
tant river in Hallamshire, was also known as the Dun ("dark"),
but may originally have been the River Danu, after the Celtic
goddesswho is remembered by the name the Romans gave to the
river at Doncaster (Danum).

It was here at St Sepulchre Gate south of the Roman fort which
lies beneath Doncaster Parish Church, on the site now occupied
by the Yorkshire Bank, that a stone altar dedicated to the Celtic
Trinity of Mother Goddesses was discovered in 1781. The altar
dates to the second or third century AD, and the names scratched
upon it are of native Celtic tribesmen. It may have come from the
site of the "Diana's Temple Well" referred to on a map of 1586.

An old rhyme referring to the river, recorded by Joseph Hunter,
runs:

The shelving, slimy river Dun,
Each year a daughter or a son.

It is possible this points back to a time when human or animal
sacrifices were offered to the gods of the River Don. Many rivers
were once believed to demand a quota of victims – the Dart in
Devonshire and the Ure in Yorkshire took one life a year; the
Ribble in Lancashire was happy with a sacrifice every seventh

year, but could be appeased by the offering of a bird or a small animal.

Lady's Bridge, the site of a medieval crossing of the River Don below Sheffield Castle. A small chapel of Our Lady was once here, the Lady being a female spirit of the river. (Photo: Sheffield City Libraries)

The river Don may have had a similar sinister reputation, for there are place-names along its length which appear to refer to water spirits. The valley of the Don as it flows past Stocksbridge is associated in legend with the Dragon of Wantley, and the name of one settlement along its banks may originate in a belief about a water goblin. The name is pronounced 'ootibridge' and is recorded as Uhtinabrig in 1161. There is an Anglo-Saxon word "uht" or "wuht", meaning a thing or demon. Oughtibridge may mean "demon's bridge", because places where bridges crossed water often had a fearsome reputation.

Not far away the name Nico Busk is found on a plan of 1778, referring to a narrow strip of woodland adjoining the Don at Wadsley. "Nico" is from the Norse "Nykr", Anglo-Saxon "Nicor" meaning a water goblin, as found in the words Old Nick, a word for the devil. Addy believed the name Neepsend, found near the city centre, may also refer to this spirit of the river. In Rotherham, the word is found at Nicker Wood near Todwick, and at Ridgeway in Sheffield the same word is found at Nicker Lands, a field which slopes down to a stream called the Robin Brook at Carter Hall Farm.

In Anglo-Saxon mythology "the deep forests and marshes were the abodes of monsters and dragons; wood spirits bewilder and decoy the wanderer to destruction; the Nicor's house by the side of the lakes and marshes; Grendel, the man-eater, is a 'mighty stepper over the mark', and the chosen home of a fire drake is a fen" (Kemble, *The Saxons in England*).

These monsters must have formed part of the supernatural world for the people who lived in the water-logged regions on the northeastern boundary of South Yorkshire, settled as early as the Bronze Age. The eighth century Anglo-Saxon Tribal Hidage listed the people of Hatfield, who lived in the vast tracts of marshland where the old Rivers Don, Idle and Torne meander towards the sea, as a distinct group on the current county boundary with Humberside.

Although only ten miles east of the Roman settlement at Doncaster, until the late 17th century when the fens were drained by Dutch engineers, the inhabitants of Lindholme and the Isle of Axholme lived in geographical isolation on islands in the middle of these wetlands. This was a strange area where old customs and beliefs lingered, including one legend about a mysterious hermit known as William of Lindholme.

He was described as a giant who tossed around great stones, and as "a wizard, magician or enchanter in league with infernal spirits or demons" who lived in a hermitage made up of two large megalithic stones on an island in the middle of a peat morass. When antiquarians visited this "hermitage" in 1727 they

found a isolated cottage with the appearance of a small chapel, with an altar at one end and a stretch of causeway running from it towards Thorne Moss. The account says they caused a huge slab of stone known as the hermit's grave to be lifted "and digging under found a tooth, a skull, the thigh and shin bones of a human body, all of very large size . . . in the grave was a peck of hemp seed and beaten piece of copper."

Near this mysterious "chapel" was a well of clear spring water, blessed by the hermit, who seems to have been a dim memory of a marshland god or fairy once worshipped here. One tale describes how he pledged to build a causeway across the marshes for a farmer "on condition that the rider should not look behind him". Of course the farmer did look and saw the hermit "in the midst of hundreds of little demons in red jackets macadamising as fast as possible . . . the terrified horseman exclaimed "God speed your work" which put a stop to the whole business and left the good people who had to pass and re-pass from Lindholme to Hatfield, to wade through the bog for two hundred years longer."

The bog spirits in red jackets mentioned in this legend may be compared with the 13 villagers known as the Boggans (from 'boggard'?) who every year take part in the curious Haxey Hood Game, on January 6, Twelfth Day or Old Christmas Day, at this village in the middle of the great tract of marshes which make up the Isle of Axholme.

The Haxey Hood is an ancient ritual contest which resembles a huge rugby scrum between opposing villagers for possession of this strange object which may originally have been a animal or human head. In legend the game dates from the 13th century, when the lady of the manor lost her hood on a windy day and gave the Hoodland in trust to the 12 men and their lord who restored it to her.

The custom begins with a procession headed by a the "Fool" who was at one time "smoked" or dangled above a fire, before he led the crowd of villages to a half acre field and exhorted them to take part in an struggle for the hood, shouting:

Hoose agen hoose, toone agen toone,
If tho meets at man, knock 'im doone
But don't 'ut im!

After a short struggle for "sham hoods" the real hood (a thick piece of rope encased in leather) is thrown into the air and battle commences, with the aim of those participating to seize and carry it to their village pub. All the while the scarlet-clad Boggans, led by the Lord who holds an elaborate willow wand, try to prevent the hood leaving Haxey. The "sway" as the scrum is known can last many hours until the strongest side forces the hood into their village pub.

According to ethnologist E.O. James the Haxey Hood "has every appearance of being the folk survival of a ritual combat between local groups, and there can be little doubt that originally the hood was the sacrificial victim". Furthermore, it is a disturbing coincidence that Haxey lies in the very middle of what archaeologists have described as "the most important area in England for bog bodies" (people who may have met a sacrificial death in the marshy waters).

It was during the 17th and 18th centuries, when the peat mosses of the Isle of Axholme were drained that ancient remains were discovered in large numbers. These included buried prehistoric forests, ploughs, coins, a Bronze Age trackway and crouched human bodies, some of whom appear to have met a ritual death in the black waters similar to that which befell the famous Lindow Man bog body from Cheshire, found in 1985.

For example, around 1645 the naked body of a man was found in the bogs near Doncaster "lying at his length with his head upon his arm as if asleep . . . his skin hair and nails preserved his shape intire". One hundred years later a woman was found, naked except for a pair of sandals, lying "upon one side bended with her head and feet almost together." There have been at least three other similar bodies found in similar circumstances, but unfortunately no specimens have survived for examination with modern technology today, and the manner in which they met their watery end must remain a mystery.

Perhaps it is the ghost of one of these sacrificial offerings to dark waters who is spotted by villagers in Hatfield from time to time, wandering across the marshes near the air base at RAF Lindholme. He is known locally as "Lindholme Willy" and the story goes that he is the ghost of an airman killed in a crash on the marshes during the last war. The last sighting of him was in 1957 when a corporal saw a misty shape coming from the moss, walking across the runway. It was a big man, he said, dressed in an aircrew uniform, but as he radioed the control tower to alert his superiors, the figure slowly vanished into the marshes from whence it came . . .

4

Into the Dragon's Lair

"The Ravager of the night,
the burner who has sought out barrows from of old,
then found this hoard of undefended joy.
The smooth evil dragon swims through the gloom
enfolded in flame; the folk of that country
hold him in dread. He is doomed to seek out
hoards in the ground, and guard for an age there
the heathen gold . . . "

This passage from *Beowulf*, the most important surviving Old English poem, illustrates the magical role which the dragon symbol played in the heroic world of the Anglo-Saxon peoples who arrived in South Yorkshire nearly 1,500 years ago.

Although Beowulf was composed by a writer living in the kingdom of Mercia during the 8th century, it is set in the heroic Viking societies of 5th century Scandinavia, and illustrates the similarities in the beliefs held by the pagan Norse and their Germanic neighbours. The Anglo-Saxon warriors used the dragon banner as royal emblem around which they would rally in battle, as in the scene from the Bayeux Tapestry where King Harold is seen fighting beneath a standard which clearly bears the image of the fabulous beast.

The English peoples also firmly believed in the existence of their dragons as a symbol of evil, with "fiery dragons flying through the air" in Northumbria seen as a portent of famine and Viking attacks in the Anglo-Saxon Chronicle of 793 AD. But most important of all, dragons were located in the landscape where they functioned as protectors of hoards of ancestral treasure in burial mounds, like Boewulf's foe the monster Grendel who "for

three hundred years held the vast treasure hall under the earth".
Like Grendel, they would fly out and ravage the countryside
when they were disturbed, a belief that lived on so long in old
England that it gave rise to dozens of local legends and traditions.

In place-names, a charter of 942 AD records Drakelowe "the hill
of the dragon" near Burton-upon-Trent, and nearer home was
Drakeholes "dragon hole" at Wiseton in Nottinghamshire, Drake
House and Drake Lane near Ormesmedwe (dragon's meadow) at
Beighton, and Wormshill at Whiston, Rotherham. There was
another hillock or burial mound near Maltby, Rotherham, known
as Drakehowe (the Dragon's Mound) recorded in 1335 and mar-
ked as a tumulus on a map of 1841. This has left no trace, but the
name shows the link between dragons, burial mounds and high
places in this region.

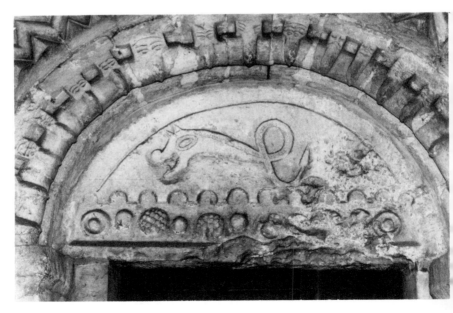

Dragon on tympanum, church of St Helena, Austerfield, near Doncaster (Photo: author)

Many old churches contain carvings of dragons and serpents which the Christian church used as a symbol representing evil, the devil or the elemental forces of nature, tamed or slain by St George or other dragon slaying archangels like St Michael and St Margaret. One of the earliest dragon carvings in the county is found on the Norman tympanum at the historic church of St Helena at Austerfield near Bawtry; there are others in the churches at Everton and Tickhill, nearby.

The church at Conisbrough near Doncaster is regarded as the oldest building in South Yorkshire, and is thought to embody the remains of a Saxon minster church built around 750 AD. In the south aisle of the church are a number of stone slabs with pre-Conquest carvings, the most interesting of which is a beautiful carved tomb-chest. It was found in the graveyard, and contains a carving of a knight with a sword and shield fighting a sulphurous dragon, with a sinuous tail. Behind him stands a bishop, and around them are zodiacal symbols. The chest has been dated to the 12th century, but the presence of ravens on another part of the chest may indicate it is much earlier, and possibly of Danish origin.

A former vicar of Conisbrough connected the carvings on the chest with a local legend concerning a spring known as the Serpent's Well on Conisbrough Cliffs, to the east of the town near the River Don. The story, told by C.H. Alport, runs: "A thirsty traveller one day stopping to drink at this spring was attacked by a snake or serpent. A struggle ensued, in which blood was shed on both sides, which took such deep hold on the soil, that some of the stones about there are still tinged with red." Another version says the creature sprang out of the jug the man was carrying, and "over and over the two rolled until they reached the spring, where the man eventually crushed his enemy, thereby permanently discolouring the stones."

Recent investigations by researchers Phil Reeder and Rob Wilson have located the possible site of the Serpent's Well beneath the limestone escarpment of the cliffs, where a chalybeate (iron-bearing) spring hidden by thorn and bramble stains the stream

below it red, just as the story describes. Not far away is Drake Head Lane, known as "Drake Head" in 1764, with the probable meaning of Dragon's Headland, a reference to the cliffs. Other place-names in the area which add to the aura of magic are Fairy Hole Flat Quarry and Hangmanstone Close.

The connection between dragons or serpents with springs or water sources is found elsewhere in South Yorkshire, and at the picturesque village of Cawthorne near Barnsley is another Serpent's Well, formerly located in a field to the east of the vicarage. The Rev C.T. Pratt, in his history of the village in 1882 described how the waters of the well had been utilised in recent years to supply the lower end of the village "before the tradition has quite died out, which makes a serpent periodically fly across to it from Cawthorne Park."

Memories of the serpent or dragon tradition live on in the village, because in Church Street, formerly Maypole Hill, stands a 19th century stone cross, built into the base of a trough containing water, which is exquisitely carved with a number of twisting serpents biting their tails. Two more dragon-like creatures appear on a Norman font, found in the grounds of Cannon Hall and now inside the church, which may like the cross commemorate the lost serpent tradition. Inside the church, St Michael and St George, both with attendant dragons, appear in the stained glass windows.

The Dragon of Wantley

Flying dragons, treasure and magical wells are the necessary ingredients of classic dragon folklore and they all play their parts in the best-known surviving South Yorkshire legend. This was connected from ancient times once again with the valley of the River Don, for here haunted of yore the fabulous Dragon of Wantley . . .

> *Old stories tell how Hercules*
> *A dragon slew at Lerna*
> *With seven heads and fourteen eyes*

> To see and well discern – a
> But he had a club, this dragon to drub,
> Or he had ne'er done, I warrant ye
> But More of More-Hall, with nothing at all
> He slew the Dragon of Wantley.

This verse opens the ballad *"True Revelation of the dreadful combat fought between More of More Hall and the dragon of Wantley,"* but the authorship, origin and true age of this dragon-slaying legend are shrouded in mystery. Reprinted in Bishop Percy's *Reliques of Ancient English Poetry* (1767) the ballad was originally issued as a popular broadsheet "to be sung along to a pleasant tune much in request." It consisted of 19 stanzas, each of eight lines, but some phrases were edited from 19th century reproductions because of "certain expressions which, for their coarseness, would not be tolerated in the cheapest broadside." Today the legend retains its popularity, for as recently as October 1993 schoolchildren recreated the ancient story of good versus evil in a pageant to celebrate the extension of the Steel Valley Walk at Stocksbridge, complete with a giant Chinese-style monster!

The Wantley legend describes how in times of old there existed on the outskirts of Sheffield a vile and sacrilegious dragon with "two furious wings, a sting in his tail, long claws, and four and forty teeth of iron". The dragon's lair is described thus:

> In Yorkshire, near fair Rotherham
> The place I know it well;
> Some two or three miles or thereabouts,
> I vow I cannot tell.
> But there is a hedge, just on the hill edge,
> And Matthew's house hard by it;
> O there and then was this dragon's den
> You could not chuse but spy it,

From its den the monster, with "seven heads and fourteen eyes" would emerge, devastating the countryside and eating up "poor children three, as one would eat an apple."

All sorts of cattle this Dragon did eat,
 Some say he eat up trees,
And that the forest sure he would
 Devour by degrees,
For houses and churches were to him geese and turkeys
 He eat all, and left none behind,
But some stones dear Jack, which he could not crack
 . . . on the hills you will find.

The story continues, with the terrified and impoverished country-folk fleeing to the protection of a local knight – More of More Hall, a curious hard-drinking, foul mouthed rascal. More agrees to fight the dragon, but requires in return:

A fair maid of sixteen, that's brisk and keen,
 And smiles about the mouth;
Hair black as sloe, skin white as snow,
 With blushes her cheek adorning,
To anoint me o'er night, ere I go to fight.
 And to dress me in the morning.

These conditions being accepted, before the battle More visits the town of Sheffield, known as early as the 16th century for its steel, and obtains a suit of armour "with spikes all about of steel sharp and strong, five or six inches long". As the people gather to watch the battle "to make him strong and mighty, He drank, by the tale, six pots of ale and a quart of Aqua-Vitae."

It is not strength that always wins,
 For wit doth strength excel;
Which made our cunning champion
 Creep down into a well;
Where he did think this dragon would drink . . .

As the monster approaches More leaps from his hiding place and strikes it on the mouth. In reply the dragon spat – "Good lack! How did he stink! Beshrew my soul, thy body's foul . . . Sure thy diet is unwholesome." Then a terrific battle begins, lasting "two days and a night", and after resisting all the monster's attempts to

devour him, More finally kills it with a carefully-aimed blow from his spiked boot – up its backside! After "turning six times altogether, sobbing and swearing" the dragon finally dies.

Wharncliffe Crags and Wharncliffe Lodge above Stocksbridge, the setting for the medieval legend 'The Dragon of Wantley'. (Photo: author)

The Dragon of Wantley springs from the same background as many other British dragon-slaying legends, including the Lambton Worm and the stories of St George and St Bevis. There are the same ingredients: the dragon's den is a cave, mound or hill, its connection with a well or water, the eating up of human beings and the ravaging of the countryside before its destruction. There can be little doubt that whoever composed the ballad had a sound knowledge of other dragon folklore, and may have worked these elements into a local legend. Although the verse is vague as to the location of the dragon's den, there has never been any disagreement that the setting was Wharncliffe Chase and Crags, a high rough pasture and wooded estate northwest of Sheffield.

Although the title of the ballad specifies Wantley, the name

appears to be a corruption or vernacular term for Wharncliffe. The word could also be a mixture of the words Wharncliffe and Wortley, for historians have connected the ballad with the noble Wortley family whose ancestral home was at Wortley Hall, a short distance from the chase and crags.

In 1252 the Wortleys obtained permission from the king to create a hunting chase in the area, and in 1510 Sir Thomas Wortley, knight of the body to four English kings, built a fine hunting lodge on the highest point of the crags. Although the original lodge is no longer in existence, the new structure replacing it stands on a flat rock inscribed with the words: "[he] caused a lodge to be made upon this crag in the midst of Warncliff for the pleasure to hear the hartes bell, in the year of our Lord, 1510."

The enlargement of the chase which followed the building of the lodge was carried out in a cruel manner, and Sir Thomas is said to have forcibly removed freeholders whose lands bordered on the chase. Two hamlets were depopulated, and one account described how he "beggared them and cast them out of their inheritance, and so the town was entirely his, which he pulled quite downe, and laid the buildings and town fields even as common."

Writing in 1819, Joseph Hunter in *Hallamshire* said the surviving traditions of this violent period probably gave rise to the dragon legend, with a satirical author drawing upon elements from romantic fiction, mainly the story of St George and the Dragon. However, in a later work Hunter says: "that it was composed in reference to Sir Thomas Wortley's inclosure of Wharncliffe I now think cannot be sustained; neither that it was composed while still the family of More resided at More Hall . . . [since] from the first year of the reign of Edward IV [1547], there has been no More living at More Hall."

Hunter goes on to chose 1591 as the date for the origin of the ballad, for the extension of the hunting park at Wharncliffe did not reach its final stage until 1589. Violent scenes accompanied the completion of the park, and in the 1590s a lawsuit was in progress between Sir Richard Wortley and his neighbours over a tithe

dispute. The charges were that on one occasion in 1591 Gilbert Dickenson of Barnes Hall, William Dickenson senior and junior, William and Ralph Broomhead and one other entered the chase – hunting, destroying stoops and rails and shooting at a bull owned by Sir Richard; later that same year these same men and six other re-entered the chase and began to overthrow stone walls. In January 1592 a more sinister happening was reported when the men "killed a deer in the park, and hung the flesh upon gallows and attached a deer's head and a libellous inscription to the church porch at Wortley."

The Wortleys were supported in their charges by the vicar of Ecclesfield who claimed that three of the men "were persons suspected of many disorders and misdemeanours" including the killing of lambs, hanging horses' heads and other bones on poles, wrecking of ploughs and the breaking of walls. Despite the serious nature of these allegations it would appear the case against the men failed. In 1605 Dickenson was granted a general pardon and it seems that because of the almost ritual nature of the violence, the men were able to claim some justification for their attack against the tithes and the enlargement of the hunting chase.

Among the names of those charged was George Blount of Eckington, who bought More Hall in 1597. Some writers have identified him as the "More of More Hall" named in the ballad, who is sometimes depicted as an attorney championed by the freeholders against the tithes imposed upon them by the "dragon" (Sir Richard Wortley). Although the accounts differ over names and dates, there can be little doubt that violent disputes between noble and yeoman farmers occurred during the 16th century, events which could have inspired the ballad or added substance to existing folklore. As one antiquarian wrote: "There was certainly bad blood enough, seemingly, for more than a ballad; but still the dragon of Wantley if it has an esoteric meaning, seems to commemorate something different from a struggle between the payers of a customary modus and the claimant of tithes in kind."

More of More Hall

More Hall – the home of the hero championed by the ballad – is a small farmstead situated in the Ewden Valley at the eastern end of the Morehall Reservoir. The farm is overshadowed by Wharncliffe Crags which tower above it across the River Don. The Mores were of Saxon origin, with a pedigree stretching back to the reign of King Henry I (1100 – 1135) and beyond. The Hall itself is described in Joseph Kenworthy's manuscript *The Early History of Stocksbridge and District* as "perhaps the oldest house at present inhabited in the whole chapelry of Bradfield, there having been a house or aula [wooden hall] there in Saxon times. It has been rebuilt, repaired and modernised from time to time, the oldest part standing at present being built about the time of Henry VIII or Elizabeth."

The badge and coat of arms of the family, originating in pre-Conquest Hallamshire, was "a cockatrice sejant vert [in] a murel coronet" – a veritable green dragon! This same dragon appears upon a seal of Thomas del More in the year 1380. It is an interesting coincidence that a dragon appears as the symbol of the More family, the same family connected with the slaying of a dragon on Wharncliffe Crags in a ballad written in the 16th century, by which time their line had died out.

At the Norman conquest, the Mores would have been one of the most prominent of the families living in the extensive moorland parish of Bradfield, and they contributed to the building of the first stone church, beside a hilltop and in the precincts of a pagan graveyard which surrounded the mound known as Bailey Hill. On the northeast corner of St Nicholas' church can still be seen today a stone carving, described as a gargoyle, clearly depicting a dragon which Hunter said was the symbol of the More family.

To the Anglo-Saxons, burial mounds like Bailey Hill contained treasure; they were "the Hill of the Dragon" and, in the epic poem, this treasure was guarded by a monster which caused Beowulf's death. The motif has survived in modern works, most

famous of which is Tolkien's *Hobbit*. It is possible that burial mounds like Bailey Hill, and Walderslow in the same region, may at one time have had dragon folklore attached to them. Folk tradition asserts that a cache of hidden treasure lies buried inside Bailey Hill – was it guarded by the Dragon of Wantley?

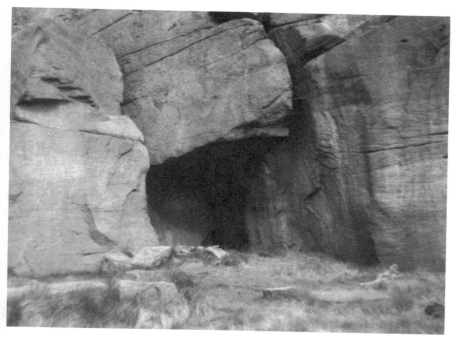

The Dragon's Den, home of the monster on the gritstone face at Wharncliffe Crags .
(Photo: author)

Traditions about the dragon linger in the neighbourhood of Wharncliffe. In Sheffield's new Town Hall, over the entrance arch is a carving in marble depicting a knight in armour killing a dragon with his sword. The guidebook states that the carving relates "not to St George, but to a local legend of the Dragon of Wharncliffe". The First Earl of Wharncliffe (1827 – 99), who bought More Hall in 1862, appears to have had more than a

passing interest in the legend connected with his ancestral lands. One of his successful racehorses bore the name of the monster, and when in the 1860s work began on a refurbishment of the ground floor billiard room at Wortley Hall he commissioned the artist Edward Poynter to produce "two pictures of legendary heroes fighting dragons".

Poynter's single painting of the battle between the dragon and More of More Hall was installed in the hall after exhibition at the British Academy. Surviving photos depict the monster in its death throes on the crag face, with the distinctive moors beyond Stocksbridge in the distance. The painting was removed for storage in Sheffield when troops were billeted at the hall during the Second World War, and was lost in the fires which accompanied the blitz in December 1940. The painting brings to mind the opinion expressed by some authorities that the legend relates to the destruction of some wild beast on the crags.

But perhaps the most puzzling reference to the legend is an account communicated to Bishop Percy by a correspondent in the year 1767. In it a traveller describes his visit to Wharncliffe Lodge forty years earlier: " . . . and it being a woody, rocky place my friend made me clamber over rocks and stones, not telling me to what end, till I came to a sort of a cave; then asked my opinion of the place and pointing to one end says: 'Here lay the dragon killed by More of More Hall: here lay his head; here lay his tail; and the stones we came over on the hill, are those he could not crack; and yon white house you see half a mile off is More Hall'. I had dined at the Lodge, and knew the man's name was Matthew, who was a keeper to Mr Wortley, and, as he endeavoured to persuade me was the same Matthew mentioned in the song. In the house is the picture of the dragon and More of More Hall and near it a well, which, says he, is the well described in the ballad."

The "cave" mentioned in the above account is undoubtedly the "Dragon's Den", which exists to this day one quarter of a mile north of the Lodge on a little path which runs immediately below the face of the crags. Nearby are the Dragon's Cellar and the Dragon's Well.

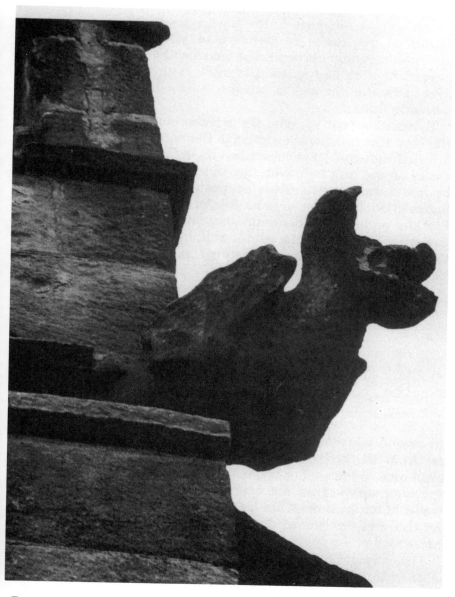

Dragon gargoyle, crest of More of More Hall, Bradfield Parish Church. (Photo: author)

The earliest reference to this cave is in a volume by the poet Taylor, dated 1639. He describes a visit to the Lodge, and although he does not mentioned the legend he says how "about a bow-shoot from thence [the Lodge] his worship brought me to a cave or vault in the rock, wherein was a table, with seats and turfe cushions around . . . "

By the 18th century, with the growing popularity of the ballad, the cave had become the Dragon's Den, and John Holland in his Tour of the Don (1864) described it as "a sort of quadrangular cavity, about four yards long by two yards wide, mainly formed by the accidentally favourable position in which a vast rock happens to lie under certain sub-incumbent masses of stone." Holland added: "Of the origin and antiquity of these remarkable caverns we have no account". Still more of a mystery is the Dragon's Well, prominently featured in the ballad as the hiding place of the monster:

Some say this dragon was a witch
Some say he was a devil
For from his nose a smoke arose
And with it burning snivel;
Which he cast off, when he did cough,
In a well that he did stand by;
Which made it look just like a brook
Running with burning brandy.

In 1767 Bishop Percy mentioned the well "still existing, and not far from the Lodge, but happily possessing none of the odour attributed to the well of the ballad". A natural spring which feeds the well survives on the crag face at the spot marked on the current Ordnance map, but there is also a second "Dragon's Well" on the opposite side of the River Don, on a hillock overlooking More Hall.

This spring, now on the border of a golf course, bears an 1818 date-stone, and the water from it was once regarded as a cure for breathing problems. Shown on old maps as Allman Well, of it Joseph Kenworthy writes: "as a youth I found that some of the

old folks regarded it as the Dragon's Well under the impression that it was the spring or well where the fabulous Dragon of Wantley sought refreshing draughts."

Folk tradition today tells of how the dragon would fly across the valley from its home on the crags to drink at the spring, linked in another story by an underground passage with More Hall, a short distance away. The connection of wells, springs and rivers with dragon legends is found throughout the British Isles, and researcher Phil Reeder has discovered that the majority of dragon place-names and church carvings in South Yorkshire fall within the land corridor formed by the River Don along which Continental invaders, with their longships adorned with dragon prows, are thought to arrived in the district.

This suggests the dragon legends are a survival of beliefs which arrived in the valley of the Don at the time of the Anglo-Saxon and Norse settlers. We know from the poem Beowulf that belief in dragons guarding burial mounds, and as martial symbols was a distinctive part of Germanic mythology. After Christianisation, the dragon became more identifiable as a symbol of evil, the Devil and the forces of nature which the new religion had suppressed.

Folklore scholar Jacqueline Simpson, author of *British Dragons*, said in her account of the Wantley legend: "Seeing how many parallels this poem has with traditional legends elsewhere, one cannot accept the theory that this lawsuit was the actual origin of the story – more likely there already was a legend either at Wantley or nearby; on the other hand it could very well be that someone versified an already existing story to make a satire on the lawsuit."

Like similar legends, the Wantley dragon appears to have some elusive connection with the landscape. Some have said the form of a dragon can be seen in the right weather and sunlight, as an image on the rock-face of Wharncliffe Crags, as the account by Bishop Percy's correspondent in 1767 appears to suggest.

Indeed, one particular rock on the crag face, between the lodge and the Dragon's Den, when viewed from the path below looks for all the world like the head of the monster. Similar "simulacra"

images have been spotted elsewhere – on the East Coast of Yorkshire, for instance, the vertebrae-shaped rocks of Filey Brigg are supposed to be the bones of a dragon killed by another hero.

The solution to the mystery may lie in the landscape at Wharn-cliffe and the beliefs of the people who settled here. What thoughts must have entered the mind of one of the original farmers and warriors who arrived in the valley over a thousand years ago, standing at the mouth of the Dragon's Den, with the valley of the Don below and the backbone of gritstone crags and wood stretching out into the distance? For in Norse mythology, were not the crags and rocks formed, like the mountains of Sutherland, from the very body of the gods themselves?

Painting by Sir Edward Poynter, of the dragon's death, Wortley Hall. The painting was destroyed in the Sheffield Blitz in 1940. (Photo: Sheffield City Libraries)

5

The Dark Months

"... as the night lengthens, and the day shortens, the ghosts gain in strength, and reach their highest at Yule time ..." (Icelandic folklore)

To the Celtic peoples, November 1, or Samhain (Summer's end) was the beginning of the New Year, the day which marked the beginning of winter, one of the two major fire festivals which divided the agricultural year. The festival is such a powerful one that it has survived to the present day as Hallowe'en, recently "revived" in popular custom, and celebrated on the evening of October 31. It was so strong that the Christian church could not uproot it, and November 1, was sanctified as the Feast of All Saints in 837 AD, with the following day made the Feast of All Souls a century later.

Long ago in pagan Britain, Samhain was a Feast of the Dead, a time for families to remember those who had passed on, when great bonfires were lit and people danced around them, special cakes were baked, effigies were burnt and burning brands carried through the fields. Folklore scholars believe it is the Hallowe'en bonfire tradition transferred to November 5, which explains the continuing popularity of Guy Fawkes Night. For, by the 17th century, the gunpowder plot had provided an excuse to re-kindle the fires and people could once again watch as the elemental flame consumed the effigy of Guy Fawkes – a new label for an ancient custom.

S.O. Addy recorded a number of place-names on high ground to the west of Sheffield which he believed may once have been spots where these "bale fires" (from a shadowy Celtic god of the sun, Belenos) were lit. He included here a field at Whirlow (formerly a burial mound), and the Bole Hills at Walkley (Tinker

Lane nearby was the former site for village merrymaking). Near
this place are the names Bell Hagg and Burnt Stones.
 "In 1637 Bell Hagg was an open common including Burnt-
stones, and containing about eighty acres," he wrote. "It was one
of the moors upon which the owners of toft-steads in the village
of Crookes turned their cattle in summer . . . it is strange that the
two names should be found together, and the explanation may be
that two large fires were kindled, the cattle being driven, accord-
ing to the ancient rite, between them."

Cakin Night

The Celtic Samhain festival was so important because it was
believed the souls of the dead were abroad at this time. When the
boundaries between light and dark, life and death, new and old
were thin, the dead returned to their old haunts and it was easier
for spirits to walk abroad disguised as men. In the upland region
to the northwest of Sheffield, a strange Samhain ceremony has
survived in the form of an event known as Cakin or Kakin Night.
It takes place each year, by tradition always on the night of
November 1, at the villages of Stannington and Dungworth, and
before the Second World War was a children's pastime.
 Stannington historian Joe Atkins says Cakin was originally a
tradition of children going rounds of their territory, dressed as
mummers in various costumes. In 1974 he wrote: "Masks were
essential to hide the caker's identity, and great trouble was taken
for authenticity in dress and no encroachment on other children's
property was allowed . . . one would get dressed up and set off
on the rounds about 5.30 and go and knock on a neighbour's door
with the call 'copper copper cake cake' this also in a false voice.
The persons in the house had to guess who the cakers were. If the
guess was incorrect money would be given, if the guess was
correct no money would change hands, but generally a piece of
parkin would be given."
 It is clear the custom had not changed a great deal until
recently, for at the end of the 19th century, S.O. Addy wrote: "On

Caking Day, which in Bradfield is the first day of November, boys and young men dress themselves like mummers and go to farmhouses collecting money to buy tharf-cake with." He describes a tharf as a circular cake made from oatmeal, butter and treacle and adds: "As All Souls' Day is the second of November it may be that the custom of eating tharf-cakes which obtains in Sheffield on the November 1, has reference to the soul mass cake formerly eaten on the Feast of All Souls and on that day distributed to the poor . . . "

Cakin Night, Robin Hood Inn, Stannington, 1991. (Photo: Copyright, The Weekly Trader/Joe Sheehan)

Today, Cakin Night survives as a fancy dress contest for adults at three public houses, the Robin Hood at Little Matlock, the Fox and Glove at Stannington and The Royal at Dungworth. On that evening a dozen or so adults gather in the bar wearing menacing, primitive disguises ranging from ghosts and ghouls, to hideous

cowled witches and werewolves, their faces always hidden by masks. These characters merely stand or move around the bar in total silence, waiting for the judgement of the landlord and resisting attempts by locals to guess their identity or to try to make them speak.

On Cakin Neet 1991 in The Robin Hood the winner was a black cowled crone carrying a mock human skull, chosen so I was told "because it was the most traditional disguise". It seems the disguises are the only part of the original "mummer" or guizer (from "disguise") tradition which survives. When the prizes of spirits and spice are awarded, masks and costumes are removed and the "spell" is broken, the atmosphere returning to that of a conventional pub.

The "Soul Mass Cake", a small fruit cake also known as poor man's parkin, appears to be missing from the custom today, but formerly it was believed that souls of the departed returned to their former haunts at this point in the year and food and drink had to be laid out for them. In some areas services were held in churchyards in memory of those departed of this life, and folklorist Brian Woodall writes that "one person told me that in olden times at Dungworth they took cakes up to the churchyard at night to leave them for the dead."

Midwinter and Christmas Customs

The Sword Dancers

All Hallow's Eve was followed by the Winter Solstice, in ancient times December 21, a pagan festival which later became Christmas. This was the true new year, when the days began to lengthen and there is hope the sun will soon return. It was at this time when the guizers appeared again, along with men in animal disguise and the long-sword dancers who performed a symbolic re-enactment of the death and rebirth of the sun in the new year.

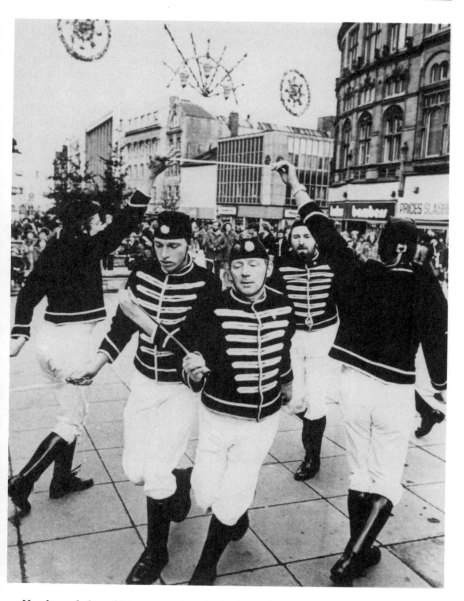

Handsworth Sword Dancers perform in Sheffield, 1971. (Photo: Copyright Sheffield Newspapers)

Traditional long-sword dances have survived in two suburban villages on the outskirts of Sheffield, and continue to be performed annually on Boxing Day near the midwinter solstice. Little is known about the early origins of the dances at Handsworth and Grenoside, but they are similar to dances found elsewhere in the North of England, and one theory is that they arrived in Northumbria with Danish settlers. Others take the elements of the dance back to Celtic times.

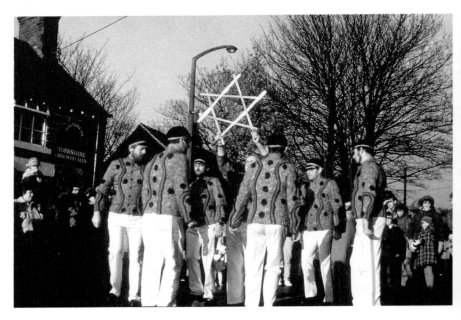

The Grenoside Sword Dance Team display the magical "lock" of swords, Boxing Day 1986 (Photo: Peter Clarke)

The team from Handsworth perform outside the village church on Handsworth Hill on Boxing Day, after an early dance at nearby Woodhouse. Handsworth was originally a mining village about five miles from Sheffield, and long ago it seems coal miners there maintained a custom of dancing around pubs to collect money and beer, later entertaining at "the big house". A similar dance was also performed by a team from nearby Treeton in Rotherham.

Although the origins of the ten-minute dance are obscure, recent research by members of the current team turned up old newspaper cuttings which show that a dance known as "the Handsworth Sword Dance" was brought to Handsworth from Woodhouse, once the larger of the two villages, in 1887.

Today the team consist of eight men who perform an energetic military-style dance wearing heavy boots, gaiters and a distinctive dragoon-type uniform, black and maroon in colour. In 1927 a previous team were presented with a new set of swords by the Master Cutler, and today the team dance with a set of 30 inch long stainless-steel swords which are not sharpened. Shortly after the beginning of the ten minute routine, the group join swords and form a complete ring, then move on to perform a series of "figures" which culminates in the famous "lock" or "nut" as the swords are woven together in the form of a star (perhaps originally a symbol of the sun), which is held aloft by one man as the crowd cheers. Formerly, the team were accompanied by two clowns, who would attract attention, collect money, and sweep out the circle at the beginning of the dance.

In the team's guide, dancer Geoff Lester writes: "Recurrent ritual elements in some of the dances, the folk plays with which they are associated, and their wide distribution throughout Europe have led some to conjecture their origins lie in pre-Christian magic. This, of course, is a matter of speculation."

At Grenoside, to the northwest of the city, there is less of a need for speculation as to the ritual nature of the dance (see Chapter 1). The Grenoside Sword Dancers wear uniforms of black caps, red-flowered jackets, white trousers and iron-shod clogs. Although clogs are not usually part of long-sword traditions, at Grenoside they add a rhythmic tramp which adds a certain magic to the performance. The clogs suggest the dance was at one time performed at least partly indoors on stone-flagged floors.

The team have six dancers, with the captain and a fiddler who provides the music. Originally the men were all miners drawn from the village and nearby Ecclesfield. Again, there are few records of the early history of the dance, but some idea of its

antiquity is given by a newspaper cutting of the late 19th century which quotes a member of the team as saying his grandfather and his grandfather before him were sword dancers. Cecil Sharp recorded in 1911 how: "the men call themselves "Morris Dancers" and explain the derivation of the term by saying that the dance originally came to the them from the Moor lands further north."

In the past the Grenoside team performed during Christmas Day on the village turnpike road, now the Main Street, then began a tour of the "big houses" in the district, including Wentworth Woodhouse, Wortley Hall and Thundercliffe Grange. Today, every year crowds of people turn up to see the dancers, some from as far away as the USA, and it gives people the chance to meet old friends they have not seen since last Yuletide.

In all probability, the lock of swords which is central to all the long-sword dancers would be part of pre-Christian midwinter magic to ensure the rebirth of the year, the growth of crops and the continuation of life. Long-sword dancers were only one part of the traditional games and customs performed from door to door and to audiences at this time of the year, and they all contain a central theme of death and rebirth.

The Old Tup

S.O. Addy wrote in 1895: "Amongst the earliest recollections of my childhood is the performance of the 'Derby Ram' or, as we used to call it, the Old Tup. With the eye of memory I can see a number of young men standing one winter's evening in the deep porch of an old country house, and singing the ballad of the Old Tup. In the midst of the company was a young man with a sheep's skin, horns and all, on his back and standing on all fours. What it all meant I could not make out, and the thing that most impressed me was the roar of the voices in that vault-like porch . . . "

Long before the arrival of the new religion, the end of December was the time of the great Scandinavian festival of Yule, with which the thunder god Thor was especially connected. In the 7th

century AD, Theodore of Tarsus in his *Penitentials*, gave a clear description of the "vain practices" carried out by the common folk at the turn of the year: "If any one on the Kalends of January walks as a stag or as a little old woman, that is to say, if they change themselves into the likeness of wild animals, or clothe themselves in the skins of cattle and wear the heads of beasts, they shall do penance for three years: for this is devilish."

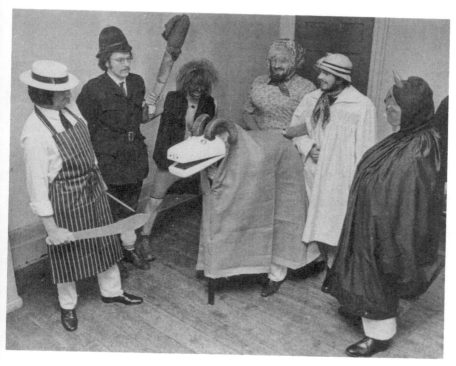

Handsworth Sword Dancers rehearse T'Owd Tup.
(Photo: Copyright, Sheffield Newspapers)

But the church had no way of enforcing these and subsequent edicts, for one thousand years later, folk were still changing themselves into wild animals at Yule, and performing other strange and patently un-Christian activities. The most popular

midwinter disguise were those of the sheep and the horse. The traditional Tup or The Old Tup remains a Christmas custom in the villages scattered across the southwestern border between South Yorkshire and Derbyshire. Five boys or more would usually go round from house to house between seven o'clock on Christmas Eve, finishing on New Year's Day. One of them, acting as the Tup would get on all fours beneath a sack, his face covered by a sheep's head made of wood, with a pair of horns sticking out at the top, two glass marbles for eyes and a tongue made of red flannel.

The most elaborate performance of the custom recorded in South Yorkshire is from Ecclesfield. Here there were several characters who performed a traditional hero-combat play involving The Butcher, Rolling Tolling Tippling Tom, Bonny Old Lass (who would appear with a blackened face and a broom), "Little Devil Dout" (who swept in the old year and brought in the new), the Doctor and the Old Tup itself.

The butcher would kill the Tup, and the doctor would miraculously bring him to life again. The group would then sing the words of the ballad, known as "The Derby Ram" or "The Old Tup", whose lines were slowly distorted as time passed, their significance long forgotten:

> *The butcher that killed the Tupsie*
> *Was up to his eyes in blood,*
> *The boy who held the pale sir,*
> *Was carried away by the flood.*
> *The horns that grew on the Tup's head*
> *They were so mighty high,*
> *That every footstep he let down*
> *They rattled against the sky.*

The song would go on to describe how the people begged for his horns "to make milking pails", his eyes "to make footballs", his wool to make eagle's nests, and his hide – said to be "big enough to cover all Sinfin Moor."

The ceremony, which probably originated with the sacrifice of

an animal at midwinter and the distribution of its body among the villagers, was once very strong in parts of northeast Derbyshire, and traditions survived until early this century in Sheffield at Handsworth, Norton, Upperthorpe, Walkley, Wincobank, Ecclesfield and Pitsmoor, and in Rotherham at Wickersley, Thornhill, Braithwell, Treeton and Thorpe Salvin.

The Old Tup was constructed like a horse, but a sheep's head commonly made of wood was used, though sometimes "a preserved sheep's head" might be obtained as at Ecclesfield and Woodhouse; and at Upperthorpe the corners of the sack were tied to represent horns. At Handsworth the Old Tup has been resurrected several times as part of the Sword Dance performance at Boxing Day, in 1971 and more recently 1991. At one time the tradition was very strong in the village, as the following account given to me by a local man, George Barton, in 1987 makes clear:

"My friends and I performed the Old Tup in Handsworth from 1936 to 1938," he wrote. "Bill Ward was the narrator, as in 'Here comes me and Our Owd Lass' and the latter was played by Douglas Batty. I was the Butcher and the late Douglas Scott was 'The Tup' for which we had a pair of horns protruding from the sack which he wore over his top half. We never used the 'fool' and only ever used 'Little Devil Dout' at a school party when Jack Gill was recruited.

"I think we obtained the words from Douglas Batty's grandfather and took over from an older grandson, John Cooper and his friends. John was to lose his life while serving with the Royal Marines on HMS Hood when she blew up in 1942. We covered most of Handsworth over the Christmas period and on New Year's Eve we were always invited into several of the large houses on the Main Road where parties would be taking place and where we never got less than half a crown from each male guest. We also performed in several local pubs. I believe we were the last ones to enact it regularly, though I stand to be corrected."

Records of the custom can be traced back only around 150 years, but the symbolism of men dressing as animals and the figure of the Old Woman clearly date back to pagan magic, as the

edicts of Theodore in the 7th century make clear. The pagan origins of the custom are confirmed by the fact that although it is performed around Christmas time, no allusions are made to the Christian festival in the words of the ballad. S.O. Addy, who recorded details of the waning tradition in 1906, observed that the ceremony was similar to a "creation myth" found in Norse mythology which tells how in the beginning of the world the sons of Bor slew the frost giant Ymir and how, when he fell "so much blood ran out of his wounds that all the race of giants were drowned in it."

The story goes on to tell how they made the sea from his blood, the rocks from his teeth, the earth from his flesh and the heavens from his huge skull, as the verses of the ballad appear to describe. The "Old Tup", he concluded "was therefore a representation of the giant Ymir, and the Christmas mummers were enacting the ancient drama of the creation."

A slightly different tradition was found in some of the North Derbyshire villages, and also in Sheffield and Barnsley. Here the "Old Horse", represented by a horse's skull on a pole, with the body made up of a tarpaulin, went from house to house bringing luck to the threshold on New Year's Eve. The horse was a sacred animal to the Celts, and this tradition seems to be connected with fertility, grafted in some counties onto the Christian custom of soliciting prayers for the dead on All Saints Day. In Cheshire, the Old Horse appears at Samhain as part of a Soul-Caking Play, and in some villages rival gangs would annually fight for possession of the horse's head, which functioned as a fertility-bringing good luck charm.

"Poor Old Horse" has been acted in Coal Aston, Dore and Totley over the last 60 years at the New Year by members of the Adlington family from Dronfield. They visit houses and pubs there with "the horse" which is actually the skull of a pony which fell down a quarry. The skull is painted black and beautifully decorated, it is held up on a pole by one of the men who manipulates the hinged jaw and acts out the words of another ballad, "Poor Old Horse", sung by two other men.

The Bull Week

Christmas was also the time of year connected with a more grisly rite when a bull was sacrificed. Joseph Hunter wrote in 1829: "When bear-baiting was among the amusements of a low population, the person who kept the bear was known as a bearward. This gross amusement seems to have run out with the last century. Bull-baiting has disappeared from Hallamshire long before, but the memory of it is preserved in the name of an open place near the market, called the Bull-Stake."

The term *Bull Week* is peculiar to Sheffield, and Hunter defined it as "the week before Christmas, in which the workpeople of Sheffield push their strength to the utmost, allowing themselves scarcely any rest and earning twice as much as in an ordinary week to prepare for the rest and enjoyment of Christmas."

Phrases such as "they've gotten t'bull by t'tail" and "they've gotten t'bull dahn", used by workmen when speaking of bull week show clearly the origin of the phrase is to be found in bull-baiting – "the custom is a relic of the time when bulls were sacrificed by the village priest, and after due oblations were made to the gods, the body was divided among the people. such sacrifices seem to have degenerated into bull baitings" (S.O. Addy). A writer in 1855 described how it was customary for the employers of Stannington to club together for the purchase of a bullock which was roasted whole on Christmas Day, then distributed among the workpeople.

In Sheffield town centre, it was under the very shadow of the Parish Church that the bull was tied to the stake before its savage death. Harrison's Survey of 1637 mentions "a croft called Skinner croft, alias Bulstake croft, lyeth next new lane west and Church lane north", and the accounts of the Town Trustees show frequent payments to a body of men described as the "waits" or "minstrels" who would have conducted the ceremony.

Popular customs and pastimes were not always the colourful and well-mannered occasions they have sometimes become today.

Of the "Christmas Wassails" in Sheffield, the autobiography of Samuel Roberts in the late 18th century noted how: "Six or eight families, of which my father formed one used each in turn to hold such a festivity, but they had even then lost much of their peculiarities, though continued as supper festivities."

The word *Wassail*, is from the Anglo-Saxon *wes-hal* meaning "be of good health". One of the characters in these games would dress up as "a hobgoblin with glaring saucer eyes, and an enormous wide flaming mouth . . . it consisted of the skull of a horse, covered with black frieze, the eyes of convex glass, the underjaw made to open, the mouth painted red. A black rug hung down from the head, inside of which was a man with a light."

After Christmas, the Twelfth Day was once marked by another feast in South Yorkshire. Addy writes: "I was told by a Hallamshire man that families in this neighbourhood used to watch the sky during the whole of the twelve days. They did this as they believed that as the weather of the twelve days was, so that of the next twelve months would be. To do this properly they watched by night as well as by day, and took it in turn to sit up and observe the sky. On the last day they had a great plum cake or pound cake."

He adds: "A century ago the bakers of Sheffield used to bake immense Twelfth Cakes, as they were called, and on one occasion Benjamin Walker, a confectioner in High Street, made an unusually big one, which was baked in sections and paid for by subscription."

6

The Haunted Realm

In ancient times spectres, omens and nature spirits were as much a part of everyday life as television and video games are to many people today. These largely lost beliefs live on in the place-names of the region today which fossilise the names of mythological beings and other objects of superstition among the Celts, Anglo-Saxons and Danes who settled in the valley of the Don, and whose own mythology intermingled with that of the people they found here.

There are many traditional spooky spots around the county, and indeed there has been enough material for one local author to write two books on the ghosts of Sheffield, a city which has a rich history of hauntings of every shape and description. One of the best known spectres is that of a chambermaid which haunts the Victorian building housing BBC Radio Sheffield on Westbourne Road, Broomhill. There are dozens of accounts of this ghost, many of the them drawn from the testimony of independent eye-witnesses, but ghost-hunters should consult Valerie Salim's *Ghost Hunter's Guide to Sheffield* (1983) and *More Sheffield Ghosts and Where to Find Them* (1987), for a complete listing of dozens of haunted pubs, stately homes and terraced houses in the city.

Here we are concerned with ghosts in legend and folklore, for in the days before the introduction of street lighting and television, ghost-scares were an exciting distraction for South Yorkshire folk. Ghost stories spread rapidly by word of mouth, and crowds would soon gather outside reputed "haunted houses". In the Victorian period there was a lot of interest in the spirit world and the Sheffield historian Henry Tatton, writing in *The Sheffield Independent* in 1934, described ghost stories he remembered from

childhood, including one in a house on Pearl Street, Sharrow (now demolished), in 1881.

"Every night at a certain time there were mysterious knockings and the house used to shake," he wrote. "Crowds congregated in Pearl Street to hear the spirit knock, and many people were afraid to pass it at night. Then there was the George Street ghost, which operated where the side entrance to the Victoria Hall now is. At that time it was a wine and spirit merchants, and every night at a certain hour a white apparition appeared in the doorway. After investigation it was found to be caused by the reflection from a gas lamp just round the bend, which threw a light on a figure in the doorway. There was another haunted house in Fountains Square, where Martin Street is now, and they could not get anyone to live in it, and another on Mushroom Lane at Weston Park."

Not all ghosts appear to be the spirits of departed people who once lived on this earth. Hauntings by vague female figures are very common, and there are White Ladies and Grey Ladies a-plenty throughout the county. These ghosts are known in folklore throughout Britain and may be the memories of a goddess of water and wild nature rather than of real women – a vision which can only be seen by the right people at the right place and time.

In Sheffield there is the White Lady of Wadsley Common, a ghost recorded in local legend and backed up by sightings both in 1920 and as recently as 1985. She is said to be the ghost of a mother, Mary Revill, murdered by her husband in mysterious circumstances inside a cottage on the common in the early 19th century. Her husband, a gamekeeper, was never convicted of the murder and was later found hanged from the rafters in the same cottage. This story was made all the more eerie because the site of the haunting was only a stone throw from the remains of a gibbet post where the body of another murderer, Frank Fearn, was hanged in 1783. The gibbet post remained standing on Loxley Edge until 1810, when it was used for the building of a wooden footbridge across the River Loxley.

Not far away, another White Lady haunts the driveway at the

isolated and ancient Strines Inn on the Bradfield moors, and still another is found in Sheffield at Beauchief Hall, walking the grounds near a fishpond. The White Lady of Hell-Clough, near Lightwood Lane at Norton, is more of the "fairy" variety, and has been seen rising up from a pool and gliding across a field and into a wood.

The names of many of these forgotten nature spirits are recorded in dozens of place-names throughout South Yorkshire, and Ecclesall in Sheffield was described by Addy as one area rich in mythological place-names. Historians today agree the place-name "eccles" found at Ecclesall and Ecclesfield (and perhaps at Ickles, near the Templeborough Roman fort) refers to the site of a British church which survived as a ruin after the arrival of the Anglo-Saxons. But Addy wrote that "there is a Middle High German word *hackel*, Dutch *hecksel*, meaning a witch . . . if Ecclesall and Ecclesfield mean witch hill, we may compare them with Sparken Hill near Worksop (wise woman's hill)."

Ecclesall, then – or *"hecksel-hallr"* – may refer to a sacred hill or mound rather than a British (Celtic) church – of which no evidence has survived. Within the parish of Ecclesall, on high ground, is a place known as Dobbin Hill. A chapel was built at the foot of the hill by the monks of Beauchief Abbey in the 13th century, and the word appears to refer to Dob or Dobby, a word for a female spirit or goblin. The name is also found at Dobcroft Road, nearby, and at Dobbin Lane near Dronfield. The male equivalent is Hob, or Robin Goodfellow.

In folklore "the ladies" was often a word used to describe the fairies, or little folk. Endcliffe, at Hunter's Bar in Sheffield, was written as El-cliffe in 1333 and again in the 16th century, and probably meant "elf-cliffe", a haunt of fairies or nature spirits. Not far from Endcliffe Park is a place known as Machon Bank – once again "fairy ground". In 1895 S.O. Addy wrote: "I am acquainted with at least four places which are known as Machon Bank, "machon" being here equivalent to Maykin, little maid, elle maid, nymph or even witch. The name is evidence of a belief in fays or hillfolk who were once supposed to haunt these places."

S.O. Addy has compared the local word "mag" with the Latin for enchantress, and he points to the place-names Maggat Lees ("maid meadows") at Holmesfield, Mag Field at Ecclesall, Magathay (Maugerhay) at Norton, and others. Maiden refers to fairies or nature spirits who haunted mounds and hillocks, trees and springs, as at Maiden's Hillock, a field-name at Dore. The expression "By the Megs" or "By the Meggons" was once used as an oath in South Yorkshire and Derbyshire, and may originate from the Anglo-Saxon, meaning "By the Powers", a reference to the Old Gods.

Meggon Gin Hollow is a lost place-name on the A625 Hathersage Road west of Dore, where cross two ancient bridle ways.

In the 1920s, an old resident said the tradition concerned two sisters, Margaret and Jane, who were lost in a snowstorm and whose bodies were found in each others' arms when the snow melted in this hollow.

Addy was convinced the names in this moorland area were much older, and referred to mythological giants. He wrote: "Before we reach Houndkirk Hill the road makes a sharp bend and we cross a deep and weird valley, which lies at the foot of this hill and is called Meggon-Gin Hollow. Below, and on the other side of the road is the Giant's Chair. Meggon may refer to the titanic power which, according to the old fables, scattered the great stones on Han Kirk Hill, Gin being an opening or narrow valley. The Giant's Chair is not marked on the maps, but is remembered by the old inhabitants, several of whom have mentioned it to me."

The present Houndkirk Hill is named on old maps as Han Kirk Hill, which Addy took to mean "the Giant's Church Hill", a reference to the giant or giantess who it was believed had scattered the giant stones found there. The Devil's Elbow is no more for in 1930 road improvements were carried out and the sharp hairpin bend disappeared. The large rock or stone called the Giant's Chair was long gone by this time, broken up at the time of the Dore Enclosure Act of 1809. But these three names in close

proximity suggest a long-forgotten mythological landscape once existed on these wild moors.

Belief in giants, giantesses, elves and dwarfs are part of German and Norse mythology, and names like these probably arrived with settlers in the Dark Ages. Their belief and mythology was probably not too dissimilar to those of the Celtic tribes they found here, and a mixture of languages has left us with our present place-names.

Mythology and reality merge at a magical spot in the parish of Bradfield, northwest of Sheffield, where the presence of those dwarfs from Scandinavian mythology live on in the landscape. From the Bar Dyke, take the minor road towards Wigtwizzle and you will pass a group of strangely-shaped hills, covered in green and stunted trees, which resemble miniature drumlins but are, some say, the burial places of the dead from a long-forgotten battle.

These artificial-looking hillocks are known as the Kenyer or Canyards, and the small valley in which they stand is known as "Dwarriden", meaning "the valley of the dwarfs". And for good reason. The Rev Gatty, former vicar of Ecclesfield Church, in his "Life at One Living" (1884), wrote: "Mr Henry Bradley derives Dwarriden from the Anglo-Saxon Dweorga-denu . . . and he begged me to go there and see if there was any peculiar echo as the Norse term for echo was "the voice of the dwarfs". I paid a visit to the spot in the spring of this year, just when the larches were putting out their fairylike buds of green; and these with the darker foliated Scotch firs and pines, growing among these strange mounds of hills, made the scene resemble some abode of elves. I shouted, and echoes on all sides answered me. This is an apt illustration of the values of names in a district."

Barghasts and Boggards

There was once a saying in Rotherham: "Tha comes and tha goes like the Thorpe Hesley Boggard!" But what is a boggard? He is a confusing creature, a terror when South Yorkshire was a collection

of rural hamlets clustered around a market place and church, and when the unlit tracks, country lanes and forests harboured unimaginable horrors.

The boggard has a relative, the barghast, often described as a fearsome creature like a black dog with huge eyes like saucers, and sometimes sharp teeth and tusks. The name comes from an Anglo-Saxon word meaning demon or hill-spirit, and it was said this creature could be seen near old buildings, streams and crossroads at twilight. Addy described the barghast as " . . . a being which resembles a large black dog, having eyes like saucers. One of these beings is said to have appeared at 'three lane ends' on Bury Hill, Holmesfield. The woman who saw it there said it was invisible to her sister, who died a month afterwards."

But it is the boggard (pronounced "boggart") who is better known today; these could appear in many forms, as dogs or other animals and headless figures. The Thorpe Hesley Boggard was supposedly the ghost of the Earl of Strafford, Thomas Wentworth who was beheaded in 1641 on Tower Hill, and his body buried in secret at Hooton Roberts, near Rotherham. It is said that at certain times he walks down Haigh Lane from Wentworth Woodhouse carrying his head under his arm, and he is also said to haunt the oak-panelled corridors of Wentworth Woodhouse, the beautiful historic mansion occupied by the family for hundreds of years.

In Sheffield, at Worrall, near Oughtibridge, a legend about another wandering spirit inspired the naming of Boggard Lane, a narrow twisting footpath, overgrown with trees in parts and overlooking a cemetery at one end. Valerie Salim comments that despite the building of new housing estates in recent years, this area retained its wild reputation. There are two haunted houses nearby, including Onesacre (known as "Sheffield's Wuthering Heights") and The Asplands on Boggard Lane, which has a resident spectre, that of a wood-turner.

But the most famous boggard in South Yorkshire has to be "The Boggard of Bunting Nook". Addy said of it in the late 19th century: "Crossroads are often haunted by barghasts, boggards or headless women. Thus the boggard of Bunting Nook used to

appear by night at a spot where three roads meet – a dark, umbrageous place, and was held up as a terror to children." The Nook, which runs along the eastern edge of Graves Park near Norton Church, has changed very little over the years, and has retained its eerie reputation locally, along with its high banks and overhanging trees which keep the lane in shadows even on the brightest day.

Boggard Lane, Worrall, a spooky spot, named after a Northcountry ghost. (Photo: Copyright The Weekly Trader/Peter Hague)

Ghost-hunter Valerie Salim, who lives in Norton Lees nearby, says there is a legend that no birds will ever sing in the Nook, and adds that in more recent years several people have seen strange green mists in the spooky lane. There is also a tale about a policeman who saw a green human-shaped apparition appear out of a patch of mist one night in 1958 when he was standing at the

junction where the Nook meets Hemsworth Road. Perhaps, as
Mrs Salim says: " . . . the only time I've had any eerie sensations
myself was walking there, I'd read so much about it, and of the
green human-shaped mists that people see there, that your im-
agination can run riot."

*Bunting Nook, near Norton Parish Church; the boggard appears as a huge black dog and,
it is said, no birds sing there. (Photo: Sheffield City Libraries)*

The Gabriel Hounds

"When a storm sweeps over Ringinglow, near Sheffield, people
say that Michael and his dogs are passing over . . . " wrote S.O.
Addy. The Gabriel Hounds or Gabble Ratchets are north-country
names for packs of ghostly dogs known from German mythology
as "the Wild Hunt", brought to life so vividly by author Alan
Garner in his children's novel *The Moon of Gomrath*. These spectral
hounds and riders would travel through the air making a peculiar
noise, though were seldom seen. Their appearance was supposed
to be a warning of a death in the family which heard it. In 1870,

when a child was burned to death in a Sheffield house, the neighbours immediately called to mind how the Gabriel Hounds had passed overhead shortly before.

In Stannington people once believed that when one heard the Hounds death would shortly visit the neighbourhood. The strange sounds have been heard in the past at Bretton Clough near Eyam and at Kitchen Wood in Holmesfield, both eerie locations. Among those who claim to have heard them was the Sheffield poet John Holland, who described in 1861 how:

"I can never forget the impression made upon my own mind when once arrested by the cry of these Gabriel Hounds as I passed the parish church of Sheffield one densely dark and very still night. The sound was exactly like the questing of a dozen beagles at the foot of a race, but not so loud, and highly suggestive of ideas of the supernatural."

It has been suggested by some writers that the real cause of these peculiar aerial noises were flocks of migrating bean geese, flying south on dark nights upon the approach of winter. However, this explanation does not account for those who are actually said to have seen the phantom hunt, sometimes led by a figure mounted on a white horse, perhaps King Arthur, the Celtic god Lud the Long Arm or even Odin himself!

Manor Lodge and the "Hall in the Ponds"

The construction of the medieval Manor Lodge in Sheffield Park, now surrounded by a modern housing estate, was begun about the year 1525 for George Talbot, the 4th Earl of Shrewsbury and Lord of the Manor of Sheffield. At the time the hunting lodge was one of the few buildings in South Yorkshire built from stone, and as such its remains are of considerable interest to historians.

During the 18th century much of the building was destroyed and stones were carried off by locals to build smaller dwellings, so that all which remains today are the ruins owned by Sheffield City Council which are slowly being excavated and restored. The only part of the Lodge undamaged is the fine Turret House, famous as one of the places where Mary Queen of Scots was imprisoned before her execution in 1587.

It was said that Mary would take the air and watch the hunting from the top of the Turret House, and her ghost known as the Grey Lady has been seen there from time to time. There are also tales about strange happenings in the nearby Manor Castle public house which stands almost in the grounds of the Lodge. In November 1983 the landlord of the pub, Jack Wright and his family, quit the premises after they saw a ghostly figure there.

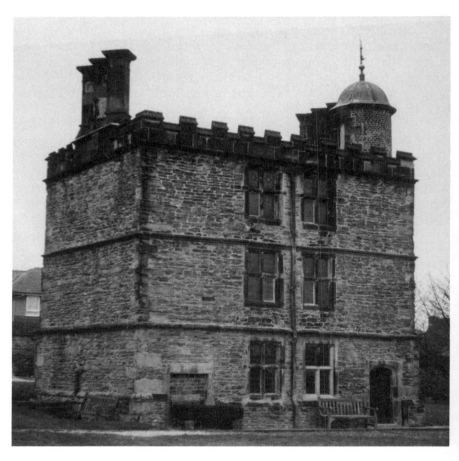

Haunted Turret House, Sheffield Manor, where Mary Queen of Scots was imprisoned.
(Photo: Andy Roberts)

Soon after moving in, Mr Wright said he saw a white figure in the bedroom. "I couldn't make out whether it was a man or a woman, but it was defiantly a human form," he said. "I thought it was my imagination at first, then the dog started barking and the ghost disappeared into the wardrobe . . . it was always as though there was someone there . . . you felt as though you were never on your own." Following this there were other "weird and inexplicable events", including the sighting of a figure wearing "gaiters and a plumed hat". Three weeks after taking up the licence, the Wrights hurriedly moved out of the pub blaming the strange happenings on the ancient ruins nearby.

Deep beneath the ruins of the Manor are said to be fabulous underground passages which link it with other places in the city. These legends are found everywhere in the country with baffling profusion, but South Yorkshire is blessed with literally hundreds of them. Tunnels are so common in Rotherham that the Local History Library maintains a file of cuttings and a log of all the stories they hear about!

In Sheffield, one of the best known focuses for tunnel visions is the city's oldest surviving domestic building, the Tudor Old Queen's Head pub in Pond Street (formerly Pond Well Hill). This ancient edifice, known formerly as the Hall-in-the-Ponds, survives today in an incongruous position beside the modern Sheffield Transport Bus Interchange and the Ponds Forge Swimming Complex. For many years the building was threatened with demolition when Sheffield Corporation were first planning a bus station nearby. At that time the building was in a sad state of neglect and when the brewery obtained a ten-year extension of the lease in 1949 extensive renovations were made inside and out.

Today the Old Queen's Head, after a £500,000 refurbishment in 1993, retains its quaint charm and aura of mystery. The building probably dates from the 15th century, and was first mentioned in an inventory of the 6th Earl of Shrewsbury made in 1582. An extract from an old account book in the Duke of Norfolk's estate office dated July 1770 refers to "an old house in the Ponds formerly the Wash-house to Sheffield Manor" and Josiah Fair-

bank, in his survey of 1820, mentions it as "Mary Queen of Scots' Wash House".

The connection with Mary (whose face appears on the inn sign) may explain the legend which says the building was linked to the Manor Lodge and Sheffield Castle via an underground passage, by which the imprisoned queen was able to travel in secrecy. This tunnel has never been found, but above ground renovations have uncovered interesting features which had been hidden and forgotten for many years. These include an old stone fireplace, tiny windows, a strip of carved scroll-work and a number of large wooden heads on the exterior walls which had been covered by centuries of paint and plaster. The carved heads, of crowned male and female Tudor characters are as old as the original timber-framed building, and were saved and re-incorporated into the interior of the pub in 1993.

One of the heads, which may represent the decapitated Mary, was originally placed in the true Celtic tradition upon the gable end of the old building, and W.F. Northend in his history wrote: "We can assume the hoted derived its title from the crowned female head, although the Queens Head is a popular name for inns all over the country, and there were other houses of that name in Sheffield."

The pub retains its reputation as one of the most haunted buildings in the city, and one of the bar-room phantoms – a little old man with jugs of beer in his hands – has been seen near the old stone fireplace which was rediscovered in 1949. The Snug was the focus of many strange happenings in the past, and although the door to the room was bolted every night it was often found wide open the following morning. The huge cellars beneath the building, where the tunnel entrance is located, as well as the mouth of a well uncovered by workmen, also have their ghosts. Footsteps have been heard downstairs, and lights go on and off by themselves. What the ghosts think of the most recent changes to their ancient home is not known.

7

Subterranean South Yorkshire

Anyone who has lived in Sheffield for any length of time will have heard the story about an underground passage which is supposed to link the Old Queen's Head pub with the Manor Lodge. This is by no means the only example – there are others linking the Manor with Handsworth Church, Sky Edge, the Cholera Grounds, Meersbrook and even distant Wadsley Hall. Others run from Beauchief Abbey to Norton Church and other buildings. Or do they?

There are so many of these stories that one is tempted to dismiss them all as nonsense, as several historians have done. But tunnel legends are not the province of historians, they are the stuff of folklore. Tunnels have survived in the oral tradition of many regions of the British Isles for generations. Many are haunted by ghosts and visions, or are the storage places of fabulous treasure, which suggests they are really a metaphor for lost knowledge or the entrance to the Otherworld. Others are undoubtedly merely tall stories, but some do seem to have a basis in fact.

In Sheffield it is the memory of the imprisonment of Mary Queen of Scots, who was without doubt the most famous visitor to the city in Tudor times, which is the basis of much of the tunnel legends. Mary arrived at the Manor in the custody of George Talbot, the 6th Earl of Shrewsbury, in November 1570 and was held prisoner there for 14 years until the Earl was relieved of his onerous duty.

Sheffield was at that time a remote and isolated place, where Elizabeth I could keep her prisoner well away from potential plots against her throne. We are told Mary left the Manor only occa-

sionally and under a heavy guard to visit Chatsworth, Worksop Manor and Buxton to take the waters. However, since Tudor times stories have become popular telling how under great secrecy she was able to travel from one place to another using a network of tunnels.

Old Queens Head, Pond Street. Sheffield's oldest domestic building with ancient wooden carved heads, dozens of ghosts and a mysterious underground passage.
(Photo: Andy Roberts)

One man who claimed to have explored an underground passage which ran from Heeley Bottom to the Castle last century "said his grandfather told him it was an absolute fact that Mary Queen of Scots was brought into the Castle by that way." Whether or not

these folktales are true, it appears unlikely if any of these tunnels do exist that they were built only in Tudor times solely for the use of Mary.

Elsewhere in South Yorkshire, tunnels are found connected with almost every ancient house, hall, pub or castle. Three of the most popular destinations for tunnels outside Sheffield are Conisbrough Castle, Roche Abbey and All Saints Parish Church in Rotherham. Here Mary Queen of Scots is replaced by Thomas Strafford and other members of the Wentworth family, and in other stories monks fleeing from their persecutors during the reformation.

In Rotherham, tunnels are said to run both to and from All Saints Church to the ancient College of Jesus in Boston Park, the medieval Chapel on the Bridge, and a number of public houses. In the town centre, tunnels run to All Saints Church from the site of the old Three Cranes Hotel on High Street, and from The Kings Arms, now W.H. Smith's store on Doncaster Gate. These were both linked to All Saints Church, and a former landlord said that his pub had a cellar "as big as a ballroom" complete with two sealed-up archways.

Outside Rotherham, dozens of passages begin or end at the Cistercian ruins of Roche Abbey, so many that one writer has commented it's a wonder the Abbey hasn't caved in! Todwick Grange, of 13th century date, was sold to the monks for farming, and is said to be connected with the abbey by a passageway, and legend tells how silver from Todwick Church was put down a well there during the dissolution of the monasteries in the reign of Henry VIII.

Other passages run to the abbey from Wickersley grange, Tickhill Castle near Doncaster, an old farm at Hooton Levitt and Bramley Grange, which was built in the 12th century as a fishing lodge for the monks. At Laughton-en-le-Morthen in 1958, council workmen uncovered a "honeycomb of gloomy passages" near the St Leger pub, which also has a tunnel to the abbey. On investigation, it was found the passages were 12 foot down beneath a four foot bed of solid rock, and stretched for a considerable distance. Because of the dangerous conditions underground, the passages were not explored and the hole was filled in shortly afterwards.

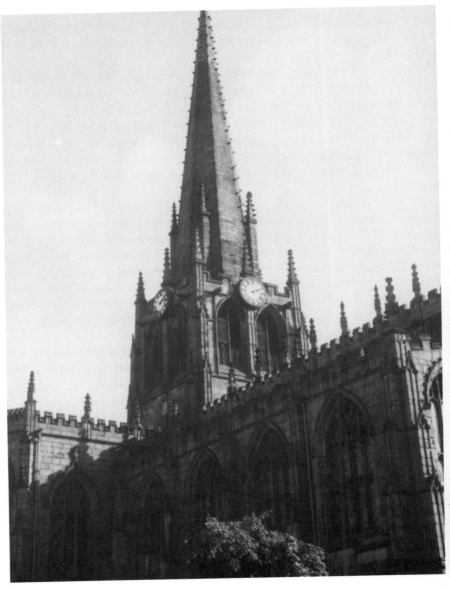

All Saints Parish Church, Rotherham, with underground passages to three public houses.
(Photo: author)

Manor Lodge ruins in Sheffield Park, the focus of mysterious underground passages.
(Photo: Andy Roberts)

Historians have always treated stories like these with scepticism. J. Edward Vickers, of Sheffield, made his position clear on the subject recently. "The fact is that never in Sheffield's history has there been any need for secret tunnels," he told readers of *The Star*. "As for there being a tunnel from the Manor Lodge to Sheffield Castle, that is ridiculous. During the Civil War, when the Castle was being attacked by Parliamentary forces, General Crawford employed a number of the best miners in Sheffield to dig a tunnel under the moat and into the castle. Whichever way they dug they hit solid rock and the idea was abandoned. The only tunnels anyone ever found in Sheffield and district were either drainage tunnels (early sanitation) or coal mines. Sometimes there were storage facilities built (as in the centre of Sheffield) but these were not tunnels."

Mr Vickers was following the tradition of Joseph Hunter who wrote in 1829, describing Sheffield Castle: "The subterranean connection between this place and the Manor, a mile and a half distant, may be mentioned to add one more to the instances of traditions so palpably absurd in connection with ancient edifices." His opinion is regarded by some as the last word on the matter. However, a passage in J.D. Leader's book *Mary Queen of Scots* published in 1880, contradicts the statement that the rock upon which the castle was built was indeed unsuitable for tunnels.

Leader described how many years earlier when drains were being dug in the town centre, a deep shaft had been dug into the rock below Castle Hill by workmen. They "cut across a subterranean passage excavated out of the solid rock, and running in the direction of the market hall, but whether it went to the Manor we cannot tell," according to his account. He continued: "It was partially obstructed with debris, but was still some four foot in height and perfect as to its roof. It was never explored. The workmen and contractors had no time to be curious, and though an exploration was often talked of, it was never made and when the shaft was finally filled up, a rubble wall was built across the passage to prevent the loose rock from falling into it, and it was once more left to damp and darkness."

This reliable account leaves no doubt that tunnels of one kind or another do exist beneath Sheffield City Centre. But are they real tunnels or just medieval coal workings and drains, ice houses and other storage places? One expert who tried to find an answer was Frank Brindley, a director of F.J. Brindley and sons, tool and steel manufacturers, who died in 1966. In his time Brindley was well-known as a writer and authority on mines, rivers and caves of the district, and in the 1930s he became keenly interested in the network of underground passages which he believed existed below the city centre.

He penned many articles on his research for the newspapers, and in one account he also described the "mysterious places" he found under the old Tennants Brewery building on Lady's Bridge, just beyond Castle Hill, mentioned by Leader. Here, he said,

"deep down in the heart of the solid rock are wide tunnels and large underground chambers cut from the living rock; clean, straight walls without a brick or stone built in them. These are deep down below the old Police Courts and offices with ramifications in every direction, spotlessly clean, and are warm with natural pure air in every part, thanks to perfection in the way the old workers had cut the air vents up shafts to the upper levels."

Brindley inspected another mystery passage, broken into near old coal workings on Sky Edge near the Midland station in 1920, and gave his opinion that it was "not a portion of any old mine, but one cut for some other purpose . . . possibly a subterranean communication between the Castle and the Manor." The passage, explored for over 40 yards was "well made of dressed rock, with a smooth arched roof six foot high. The width was two to three foot. It runs through the coal seam and bad air and coal gas made further exploration dangerous, but its direction follows the nearest line to the Manor Castle ruins. Following it the opposite way, it leads back downhill to Sheffield, probably cutting under the Midland Railway somewhere by the bottom of Duke Street. The workmanship of the Sky Edge passage is admirable. It is cut through the solid rock, and is remarkably neat."

Among the other tunnels which Brindley explored was one to which access was gained by an 80 foot shaft from a building in High Street, Sheffield. The shaft led to a tunnel running under Fargate to Norfolk Row, and he believed this was part of an ancient passageway which once connected Sheffield Castle with the Manor Lodge. Writing in 1914 S.O. Addy described this tunnel as "one of the most interesting archaeological discoveries ever made in Sheffield, but which has attracted far less attention than any other." He continued: "At the end of May 1896, when Messrs Cockayne were enlarging their premises, they found what was called "a subterranean passage" extending from the junction of the Hartshead with High Street as far as the Parish Church. As you stood in High Street you could see the opening, rather deep down in the rock, of a passage or tunnel. It was high enough for a man to walk in and it was not a drain."

The Ghost Tunnel

In 1935, workmen found another entrance to this, or another of
the tunnels which seem to riddle the city centre, below the offices
of *The Star* newspaper at Hartshead, cut from the solid rock, about
six foot in height and five to six foot wide. The discovery came
about through the story of a ghost which had appeared in the
cellar beneath the old Tramway Club, less than 30 foot from the
present offices of Sheffield's evening newspaper.

Frank Brindley, writing in 1936, said: "My friend, who told me
the story, worked in the cellar during the days when the now
dead "Tissue" was printed there as a racing paper. He saw the
ghost of a man in ancient dress, with a curious hood, like what he
says he saw in a history book at school. The ghost came from an
unused cellar and walked past him and seemed to go clean
through a stone wall. He had heard the clanking of a chain just
before, which he thought was made by his mate, but as the figure
passed he noticed it was a carrying a curious bucket, as if it
contained water."

This is not the only ghost haunting this tunnel, for others have
been spotted along its route where the Vulcan Travel Agency in
the Hole in the Road was situated. Others may wander the
network of tunnels which run beneath Sheffield Crown Court,
built as the first Town Hall in 1808 on the site of the old Castle. In
1991 court ushers told how they were mystified by a mysterious
swinging lamp, one of eight suspended by chains from the ornate
roof metalwork in Court No. 1. "While the others remain motion-
less," ran the story, "this lamp swings gently back and forwards,
sometimes twisting one way, then the other."

It was the ghost story in the Hartshead end of this tunnel which
led Brindley to explore the opening with two skilled masons. He
wrote: "The ghost story had found us the missing tunnel to the
Castle, which historians had said was in existence, but which no
one in our times had ever seen." For anyone who doubts the
existence of these tunnels, photos of the interior of the passage
under Hartshead were published in *The Star* in 1936, providing

clear proof. Brindley wrote in the article which accompanied the pictures: "We started to explore what we now call the ghost tunnel. The floor was well worn as from long usage, and bone dry, without any trace of rubbish. Its first direction was east, taking a line towards Castle Hill. It turned slightly south and then resumed its eastern direction, and when 50 foot from our entrance hall we found the first trace of others having found this mystery tunnel before. On one of the rock walls were the following letters cut deep: "I.W. 1830" then just below was "B.R.", a dash and then "T.W.W.B."

Exploring further, the men passed beyond High Street and after rounding several bends found the tunnel ended abruptly at a brick wall, probably the foundations of one of the buildings in King Street built in the early 19th century. "The situation of the mystery tunnel would be a good 40 foot below High Street level. The sewer makers who laid the drain there would not dig as deep as to cut into it. Where it was built up Castle Hill was only 500 yards away, and but for this obstruction we should have been able to have walked directly underneath the buildings of King Street, and entered the Castle at a point where the new building of the markets now stand."

He concluded: "There is no doubt that this is the tunnel mentioned in one of the old papers as running from Sheffield Castle to the Earl of Shrewsbury's house at the corner of Norfolk Row, Fargate." Frank Brindley tells of another curious story connected with a tunnel at Millhouses which was also haunted by a monk who appeared in the cellar in which the tunnel finished. "The first person, not a believer, saw her doctor, telling him her mind must be failing, and she "saw things". But a new tenant of the house, not told of the visitor, had the fright of her life when she also saw it pass through a solid door and vanish in the middle cellar. Her screams brought help and, thinking a thief had got hid a search was made but failed to find anything, except the entrance to the tunnel and this was made up with bricks and cement, and the house deserted again."

Other strange stories collected by Brindley in the 1930s included

one about a tunnel found near the ruins of an old priory by sewer makers on Priory Road, Sharrow, which ran towards Beauchief Abbey and had been explored as far as Abbeydale where a side tunnel was discovered. This contained "a stone-lined underground room in which was found a curious oak chair and table, on which was a stone jug and quaint glass alongside a pair of gauntlet gloves. In the corner stood a broadsword with a finely-worked silver handle, with part of a rusty breast-plate on the floor beside it."

This reminds one of the folktales which claim that fabulous treasure can be found hidden inside some of these subterranean passages. On the subject of the tunnels linking the Manor with Sheffield Castle and the Cathedral, Brindley wrote that "the most romantic say that hidden treasure will be found in them when a full exploration is made". Addy recorded how at Kimberworth in Rotherham at the end of the last century, the inhabitants of the medieval moated Manor House became so convinced that treasure was hidden inside a passage which connected the building with a "motte and bailey" castle nearby that they dug into the moat to a considerable depth. They found nothing.

Stories about "hidden treasure" lead us back into the realms of folklore, for it seems unlikely that many tunnel traditions refer to real underground passages, but rather something older and more esoteric, the treasure being a metaphor for that lost wisdom or knowledge. In this category must fall some of the vague traditions about outrageously long tunnels which, it is said, run from the Manor Lodge to Norton Church and Wadsley Hall (over four miles) and from the foundations of the 12th century Norman castle at Conisbrough to Doncaster town centre and Tickhill.

Rather than real passageways, it appears these stories may stem from a folk memory of a mystical connection or alignment between the old buildings or earthworks which are serviced by these mythical tunnels. Stories like these are often found concerning ancient buildings and sometimes earlier structures like prehistoric hill-forts and burial mounds, and occasionally when the routes of the tunnels are marked on a map they are found to run in a

straight line, linking sites from a number of different historical periods.

Conisbrough Castle, near Doncaster, setting for Scott's novel 'Ivanhoe' and destination point for mythical underground passages. (Photo: author)

Modern interest in mystery alignments like these began in 1925 when Herefordshire antiquarian Alfred Watkins published *The Old Straight Track*, a book described by author Alan Garner as being "full of the most romantic elements of archaeology and folklore". Watkins is credited with the coining of the term "Ley Line" (from the Anglo-Saxon word meaning a clearing), following a mystical vision he experienced whilst riding in the countryside.

Watkins believed his lines were trackways built in prehistoric times which continued in use through the medieval period, utilising many different landscape features as markers, including standing stones, beacons, holy wells, churches and even hilltop

notches. He also recorded instances of leys aligned on the rising and setting of the sun, moon and other celestial bodies at certain festivals and other important times of the year, including the midsummer and midwinter solstices.

His ideas were resurrected in the 1960s, when stories about ley lines found a new home in the works of the New Age and Earth Mysteries movements, and they seem to gain some scientific credence when several scholars claimed that Stonehenge and other prehistoric stone circles were constructed using precise geometry to act as "celestial observatories" for the people of Neolithic and Bronze Age Britain.

Today, ley hunters see Watkin's lines as more symbolic or aesthetic landscape markers rather than precise mathematical alignments, a viewpoint which archaeologists (who at one time dismissed leys as "damned nonsense") are finding more acceptable. More evidence continues to come to light which does indeed demonstrate that prehistoric man had the ability to manipulate his environment for ritual purposes and for reasons which appear baffling to modern man.

This discussion of landscape and astronomical alignments as a possible explanation for some of South Yorkshire's tunnel legends brings us to two stories with a fairytale quality recorded by S.O. Addy. One concerned an underground passage which linked Holmesfield Castle and Holmesfield Hall near Sheffield. "Halfway down the passage is an iron box containing treasure, and upon the lid thereof a cock sits which always begins to crow if anyone attempts to go near the box."

This tale was similar to a story about a tunnel linking Beauchief Abbey and Norton Church nearer the city centre, one and a half miles apart. Here Addy recorded a folktale which told how: "the box (containing the treasure) can only be fetched away by a white horse, who must have his feet shod the wrong way about, and who must approach the box with his tail foremost. The box must be tied to the horse's head and not fastened behind him."

Intrigued by this puzzling legend, earth mysteries researcher Rob Wilson plotted the route of this tunnel on a map in 1985 and

made an interesting discovery, for not only did the path of the "tunnel" pass through medieval Norton Hall, but also directly through what appeared to be a burial mound or tumulus, topped by trees, which he came across in Graves Park nearby.

"Its location is particularly interesting as it is precisely on the line between Norton Church and Beauchief Abbey," writes Rob. "Only excavation would decide if the mound is a tumulus but it must be noted that tumuli frequently occur upon alignments". Ghosts and other folklore also frequently occur on alignments, and here not only do we have a folktale about buried or lost treasure, but also hauntings both in Norton Church, Norton Hall and Beauchief Abbey (which boasts both a White Lady and a hooded monk).

Archaeologists will find speculation like this hard to accept, and will point out that the four sites featured on this alignment are all of different periods, stretching from the Bronze Age to the medieval period. However, many "sacred places" in the landscape show a continuity of use over long periods, a fact which is supported most clearly by the body of folklore and legend which grows up around them.

St James' Church at Norton has evidence of Saxon origin (including a number of archaic stone heads), and in the case of Beauchief Abbey history records its foundation in the late 12th century by Robert Fitzranulph as penance for his involvement in the murder of the Archbishop of Canterbury, Thomas a Becket. Historical documents give the foundation date of the abbey (whose name means "Beautiful Head") on a very significant date, December 21, 1183 – the midwinter solstice!

Although the line of the midwinter sunrise does not follow the alignment running through Graves Park discovered by Rob Wilson, the site of Beauchief Abbey itself appears to have been chosen as an observation point for the rising of the sun at midwinter. This alignment, discovered by the late R.D.Y. Perret begins at Bole Hill, Fulwood, and runs through Priest Hill (Ecclesall), the earthworks at Castle Dyke and ends at the abbey, founded on the date of an important pagan festival whose sunrise line it marked.

Roche Abbey, near Maltby, built by Cistercian monks which has underground passages running to Doncaster and Rotherham. (Photo: Copyright P. Fletcher, Sheffield City Libraries)

Are stories about underground passages literally true, or is there a more magical explanation for them which was known to our ancestors, but is as far out of reach in the late 20th century as the entrance to one of those mysterious tunnels themselves? As S.O. Addy wrote in 1893: "One is accustomed to laugh at such things, and to treat them as nursery tales. But they merely afford proof of the value of tradition."

8

A Selection of Spooky Tales from South Yorkshire

The Park Ghost, or 'Spring-Heeled Jack'

"Richard Rhodes, a middle-aged man, described as a cutler and a banjo-player, was placed in the dock at Sheffield Town Hall on Friday on the charge of assaulting PC Turner while in the execution of his duty. Late on the previous night the officer was passing along Whitehouse Lane, Upperthorpe, when the prisoner, who lives in the neighbourhood, rushed at him in an excited state exclaiming that 'he would settle him'. The PC attempted to pacify the prisoner who declined to listen and struck him a violent blow on the head with his banjo. The prisoner was then secured and conveyed to the police station where he made a statement that he had mistaken the constable for "The Ghost" and that, as he "was not afraid of no ghoses" he rushed towards him. The Stipendiary imposed a fine of twenty shillings and costs, with the alternative one month imprisonment."
Sheffield Telegraph, May 31, 1873.

The most famous ghost ever to appear in Sheffield is without a doubt "Spring-Heeled Jack", otherwise known as the "Park Ghost". The name is a familiar one to many people, few of whom realise it was first coined as long ago as 1830 to describe a leaping figure who for several months struck fear into the hearts of residents in the Barnes Common area of London.

His name caught the popular imagination of the Victorian age, and the strange unsolved crimes of the characters who appear to have taken on his disguise lived on in legend via the pages of the

Penny Dreadfuls, alongside those surrounding the better-known Jack the Ripper.

Cholera Monument, Norfolk Park, haunt of Spring-Heeled Jack or the Park Ghost in the 1870s. (Photo: Andy Roberts)

The scene of his appearance in Sheffield was the Cholera Grounds off Norfolk Road in the Park district. The grounds are dominated by the Cholera Monument, whose pinnacle was toppled during a fierce gale in 1990. This rocket-shaped monolith was set on a high point overlooking the Midland Station in the city centre, with a

inscription saying it was built "to the memory of 402 persons who died from Asiatic Cholera during the epidemic of 1832 and were buried in these grounds . . . the foundation stone was laid by James Montgomery, the poet in 1834 and the top stone placed in position on 11 April 1835."

Memories of the poor victims of the epidemic no doubt lived on in the area of the Cholera grounds and gave it an eerie reputation, for nearly forty years later in the spring of 1873 a rumour began to circulate that a ghost was making nightly appearances in the grounds of the monument and nearby Clay Wood Quarry.

Sheffield historian Henry Tatton, a contemporary of the scare, wrote in 1934 how: "The Park Ghost, alias Spring-Heeled Jack, could spring like a goat, and jump through fire-barred gates like a cat. It used to appear at all times of the night, robed in white, and suddenly appeared in front of people, mostly courting couples, and then suddenly disappeared when anyone tried to get a hold of it. It used to come out of the grounds of the Cholera Monument . . . springing and jumping about the quarry and over walls, and it appeared on Skyedge and Arbourthorne and all around that district. People were afraid to go out at night, and they used to carry sticks to attack it. This went on for a long time, till the people started to go out in crowds to try and capture it, and the ghost had some very narrow escapes."

Rumours about the appearance of a ghost spread like wildfire through Sheffield in those days, and steadily the accounts of the antics of this strange visitor became more and more horrific. The "Park Ghost" was described as tall, gaunt and of "unearthly aspect", he was seen "skimming over the ground with supernatural swiftness" and making huge leaps into the air and over walls.

One eyewitness told the *Sheffield Telegraph* he had seen the ghost clear a wall in one bound – no mean feat, for the wall on subsequent measurement proved to be 14ft 3in in height! Another told how, after leaping out onto two young girls he seized them and, after whirling them around, threw them over a fence. A third said the night before this prank the ghost had been shot through

the ankle by a vigilante, but bounded away more merrily than ever.

The Park Ghost appeared not only in the Cholera Grounds but also in the area later covered by the ugly Park Hill Flats, around Bernard Street, Haigh Lane, Cricket Road and the old bridle path known as Park Hill Lane. By the end of May, 1873 the appearances of the "figure in white" had become more and more frequent, and he had now been spotted on Sky Edge, at Arbourthorne, and bounding along Heeley Bank Road.

Soon, hundreds of people began travelling to the Park district each night to see the ghost for themselves and an extra force of policemen was required to restore order. On the night of Thursday, May 23, 1873, according to a report in the *Sheffield Telegraph*, "not less than two thousand persons, principally youths and young men congregated in the haunted district, much to the annoyance of residents. A numerous staff of police officers were there ready to receive them as soon as a large number got together. As might be expected the Ghost did not make his appearance, much to the chagrin of the assembled roughs."

Over thirty years later, another writer in the same paper described how he remembered those scenes in Clay Wood quarry, which later became known as "The Ghost Quarry" – the centre of epidemics of ghostly scares. He wrote: "Hundreds of people would congregate there at nights gazing expectantly at a yawning black hole underneath the Cholera Monument Grounds, the said hole being popularly supposed to communicate by way of an underground passage with the Manor Castle. Extra police were needed to keep the crowds in order, and if any juvenile was too inquisitive he was promptly and effectively dealt with by a policeman known far and wide as Owd Platts. These crowds talked of Spring-Heeled Jack who is even now shelved by the Penny Horribles . . . "

In the end, after a long series of adventures and several narrow escapes, it became too hot for the "ghost" and he ceased his nightly appearances – perhaps an indication that he really was human after all! The prevailing view at the time was that in the

tradition of the London Spring-Heeled Jack of fifty years previously he was "a young fellow of weak intellect who has undertaken to appear nightly from Easter until Whitsuntide for a wager of £50, if he frightens a certain number of individuals and escapes the law."

Human or not, the Park Ghost or Spring-Heeled Jack as it appears he became known as the years passed, became a part of the folklore of Sheffield and stories about his antics survived on the lips of old folk until the 1980s. They had heard the stories from their parents and grandparents before them, and I have spoken with several elderly Sheffielders who had memories of this ghost, some of whom claimed he continued to appear as late as the First World War in different districts of the city.

Attercliffe Common

Grimesthorpe takes its name from *grima* , in Old English "ghost", which is also a term for the Norse god Odin (grimr – "the masked one"), a name often given to huge earthworks like those at Wincobank fort and the Roman Ridge which the Anglo-Saxon tribes found on their arrival in the Don valley. Far from the modern hustle and bustle which today surrounds the Meadowhall shopping centre, in ancient times this was a strange place looked upon as a resort of elves and demons. This reputation is reflected in the local place-names, most now lost, which include both Devil Lane and Hell Hole at Brightside!

One of Sheffield's most haunted buildings stands on Attercliffe Common, the straight road which connects Sheffield with the Roman fort at Templeborough. There was a building of some kind near the site of the Carbrook Hall Hotel as long ago as 1176, but the later hall built here in Tudor times was pulled down in the late 18th century.

The present building originates at the end of the 16th century with Stephen Bright whose son Colonel John Bright led the Parliamentarian forces who attacked and captured Sheffield Castle during the Civil War. The most ancient part is the "oak room"

dating to 1623, which has fine moulded plasterwork, oak panels and a fireplace, a survival from the times of John Bright. He died in 1688 after holding office as the High Sheriff of the County of York, and now his ghost is counted as one of four which haunt the present Bass-owned public house.

Carbrook Hall Hotel, Attercliffe Common, is haunted by four ghosts. (Photo: author)

Sheffield's Society for Research into the Paranormal (SSPR) have held a number of high profile "ghost hunts" in the pub without anyone spotting anything unusual, but ghostly tales are common talk at the bar. A previous landlady, Linda Butler, claimed to have seen the ghost of a Roundhead soldier near the doorway and at the end of the bar, as well as a little old lady in a "mob cap".

The present manager, Phil Skelton said all four resident phantoms, including a former customer known as Fred, a monk or nun and a crocheting Edwardian lady, are all "friendly". Staff and regulars claim to have witnessed a number of strange goings on, including a unexplained black shadow which regularly passes the

tap room window. "The most frightening experience was when something or someone brushed past me on the stairway," said Phil recently. "There was no one there that you could see, but I felt a cold sensation and the hairs on my arm stood on end. I'm a little bit apprehensive when I'm in the pub on my own, but they are friendly and as long as they don't interfere with my spirits they can stay."

Attercliffe Common retained its eerie reputation well into the 18th century, when in the year 1792 the body of highwayman Spence Broughton was hung in chains from a gibbet on Clifton Street, near where Carbrook Hall Hotel now stands. Broughton's crime was the holding up of the Sheffield and Rotherham Mail Coach with an accomplice, John Oxley, and stealing the postbags. Broughton was later captured and hanged at York on April 3, 1792, and his body was taken back to Attercliffe, near the scene of the robbery, and left upon a gibbet post.

Ghoulish sensation-seekers flocked to see the gibbet and for some time the road was blocked by crowds. Broughton's remains finally fell from the gibbet in 1828, and pieces of his bones were collected and carved into ornaments, his thumb bone supposedly being fashioned into a handle for a beer mug. The gibbet post was used in the construction of Orgreave Colliery.

In 1985, over 200 years after his execution, Spence Broughton's ghost may have appeared in the street which bears his name – Broughton Lane, only yards from the spot where his body was hanged in chains. Three employees at builder's merchants Richard Wraggs, told *The Star* how they had seen "a strange shadowy figure" in their yard which disappeared suddenly. Brian Sheldon, the roofing manager said he thought he saw a customer standing by a cement mixer in the company's trade area. "Seconds later I turned round to serve him, but he had gone. I checked the yard, and I checked the street – but there was no one to be seen. It looked like a person in a long, dark coat, but thinking about it, it could have been a highwayman's cloak." He added: "We think it could be Broughton, One story is that his body was left hanging where our yard is now. Another is that he left some loot here – and has come back to claim it."

Ghosts down the Pits

Coal mining has until recently been the bed-rock of industry in South Yorkshire, providing jobs for thousands of men in the great coalfields which stretch from Barnsley across the Dearne Valley, southwards into Nottinghamshire. Today, the mining industry has been devastated and pits lie empty and in mothballs, ghosts of their former selves.

Colliers, like the fishermen of the East Coast, once had their own rich folklore of belief and superstition attached to all aspects of their working lives, much of which is now sadly lost. But quite often in South Yorkshire, we hear of hauntings in pit shafts which have no obvious rational explanation.

Back in 1975, a spook dubbed "the Phantom Miner" was haunting the old Wath Main pithead. He was sighted three times that year, and miners regularly claimed they had felt a "ghostly presence". Electrician Robbie Beardsley, then 21, was a sceptic until he said he saw the ghost when he was working on the coal face with six other men. He said he saw a bright light in the distance walking towards him, like the light on a pit helmet.

Will o'the Wisp, or coal gas? More "unexplained lights" in dead headings deep underground were spotted by miners in the Silverwood and Goldthorpe pits during the 1980s, and in March 1982 a Rotherham miner was so scared by a ghost in Silverwood that he vowed never to go underground again, even though a surface job meant he would earn up to £70 a week less!

Stephen Dimbleby was working underground with two friends in a deserted section of the mine when his scare began. "I looked up to see just how far they were in front of me," he said. "When this bloke appeared a yard in front of me. He looked just like an ordinary bloke at first, but when it hit me it was a ghost I dropped everything an legged it. If some blokes hadn't caught me I would have run all the way back to the pit head, which is two and a half miles. Afterwards they told me when they caught me I was wet through with sweat and clammy all over."

He said he saw the face of the figure clearly. "His face was

blank, there were no features. He had an old square helmet and he had what I assume was a waistcoat and old grubby shirt." A Coal Board spokesman said afterwards that section of the pit had been reopened to reach a new face, where a miner died in 1968. Square helmets, he said, were in common use around 10 years ago.

Two years after this sighting a bricklayer, Barry Barnett, then 29, was treated by a doctor for shock after he spotted a headless phantom in Goldthorpe pit. This phantom was wearing orange overalls! Barry said he was enjoying his lunch in a new development area when the ghost appeared. "I looked over the top of my newspaper and saw two miner's boots about 40ft away. I thought nothing of it until it started coming towards me," said Barry, of Mexborough. "As the boots came further into the light I could clearly see he was wearing orange overalls. His bottom half was transparent, his top half was a silhouette. There was no head."

He continued: "I was frozen to the spot in fright. Goose pimples were on goose pimples. The ghost stopped at the haulage ropes and stood there. If he moved any closer I was all set to run. He gradually stepped back and dwindled away into a siding."

The mystery was increased when it was revealed that no miner had been killed in the pit during this century, so perhaps the appearance was an omen of the death of the industry itself. Either way, Frank Calvert, NUM branch secretary at the pit, said: "I accept what Barry says he has seen, and he should not be ridiculed because ghosts have been spotted in the pit before."

The Kimberworth Murders Ghost

Are ghosts figments of the imagination or really the spirits of departed souls who refuse to leave their earthly homes? Whatever the explanation, a Rotherham historian believes clues provided by the ghost of a 10-year-old girl could one day provide answers to a murder mystery of over 80 years ago. The story unfolded in the summer of 1993 when a 24-year-old barmaid from Kimberworth rang the offices of the *Rotherham Advertiser* to tell how she was so

frightened by a ghost that she was afraid to walk to work along a lonely footpath near her home on the Winterhills, a steep hillside above Tinsley. Doncaster-born Jeanette Freeman said she first saw the ghost appear in the bedroom of her home one Sunday afternoon. She said she was snoozing when she heard a little girl crying. "I opened my eyes and then I could see and hear her. She was very small and wore an old fashioned dress with a ribbon tied in her hair."

The girl was asking for her dolly, saying that she had been murdered and buried in a shallow grave and also a year, 1906. The girl appeared again the following morning, and on a third occasion as she walked to work through Lady Scope's Wood near Droppingwell Lane. This time the girl said the footpath was near the place where she met her end, leaving Miss Freeman petrified and confused. But things became clearer when she visited the local library to ask whether there had ever been a murder in the area where the ghost had appeared. She was shocked to discover that although there was no record of a murder having taken place there during 1906, there had been a famous and brutal double murder of two small girls very close – in November, 1912! Not long afterwards on visiting the newspaper office, Miss Freeman dramatically identified the "ghost" as that of 10-year-old Amy Nicholson, who was murdered with her seven year-old companion Frances only yards from her home at the now-demolished Abdy's Kimberworth Park Farm, from a grainy photo published by the *Rotherham Advertiser* in 1912.

It turned out that Amy was the adopted daughter of a farm labourer, Arthur Collinson, who lived at the old farm on what was then a lonely hillside on the outskirts of town. On the night of Friday, November 24, 1912, the two girls were returning to the farm after school by a route across pitch black fields. When they did not arrive home, the family searched for them and later that night Mrs Nicholson found their mutilated bodies a short distance from the farm on a path between Kimberworth Park Road and Lady Scope's Wood. At the inquest into their deaths, a pathologist said the girls had their throats cut but died with "serene and

happy faces". He also revealed the eldest girl (Amy) had been raped – probably by the man responsible for the murders – three days before she was killed.

Hundreds of people from across the borough gathered at Kimberworth Parish Church for the girl's funeral in November. They were laid to rest together in the graveyard beneath a stone (since replaced) marked "Brutal Double Murder". On December 29 that year, after a huge police hunt for the murderer, a simple-minded showman's labourer from Mexborough was arrested and charged with the murders. The 24-year-old vagrant, Walter Sykes, later retracted his confession, but his trial was shabby by modern standards, and despite his plea that the murderer was a local man who knew the girls, he was convicted at Leeds Assizes and hanged in April, 1913.

With the help of a local historian, Kevin Turton, who was brought up in the area and knew many stories about the murder, we were able to reconstruct the events of that night and even point a finger in the direction of the man who may have been responsible for the crime. But we were never able to solve the mystery behind the ghostly girl's strange and confusing message. Miss Freeman said at the time: "I still don't understand why I have been picked for this contact, because I am not from this area and nothing like this has happened to me before. It was not the anniversary of the murder or anything like that, but do I resemble someone she knows? I was convinced that if I bought a dolly like the one she was crying for and put it on her gravestone, perhaps she would leave me alone."

Mr Turton told me: "I don't doubt Miss Freeman has been haunted by someone. Whether it is the little girl is hard to say but she is a very genuine person and has undoubtedly had these strange experiences. I do believe things like this can happen, and she is producing evidence to back up what she is saying. If the ghost is genuine it could one day provide the answer to the mystery – but can you ask questions of a ghost?"

Phantoms of the Stocksbridge Bypass

In the winter of 1987 earth-diggers and juggernauts of the McAlpine construction company began to cut a huge swathe across the hills and moor north of Stocksbridge. The landscape-changing project was the result of a plan to link the M1 with the trans-Pennine Woodhead Road, taking traffic pressure away from the town of Stocksbridge. The completed road, which cost £18 million, was opened in April 1988, on Friday the 13th. The timing was unlucky, for instead of being praised as the answer to traffic problems, in the first 10 months two motorists died and six were injured in nightmare crashes on the road.

Five years after the opening of the road, the number of deaths and serious accidents continues to grow, with eight fatalities and dozens of accidents blamed on driver errors, bad layout and design faults. Local councillors and MP Helen Jackson have called for the road to be classified as an accident black spot, and it is little wonder that the bypass has developed a sinister reputation locally. Some say the road is "jinxed" – but is it haunted too?

The strange stories which surround the Stocksbridge bypass can be traced back to the time when it was under construction. For it was in September 1987 that sightings of ghostly figures were made by night-watchmen and policemen on a section of the new road on the hillside above Stocksbridge at Hunshelf Moor. That autumn the road was in the final stages of construction, with work progressing on a stretch above the steelworks in Stocksbridge. As the evenings began to get longer and darker, the path of the new road reached Pearoyd Bridge, which carries a steep-sided track linking Stocksbridge steelworks with the villages of Hunshelf and Green Moor on the hillside above. It is said the juggernauts disturbed something.

"Terrified security guards called in police and clergymen after spotting 'ghosts' on a multi-million pound bypass being built near Sheffield," said a report by Bob Westerdale in the *Sheffield Star*. "A sergeant and police constable sent to the scene near Stocksbridge later said they 'felt a presence' as the patrolled. But South

Yorkshire police have refused to comment on the incident or on reports that the Panda car was jolted by mysterious thuds.''

The bypass was closed to the public, and a Rotherham-based security firm patrolled the area at night. On the freezing-cold evening of September 7, security guards David Brookes and David Goldthorpe were driving in a Landrover along the bypass near midnight when they saw the hooded figure of a man standing on the newly-constructed bridge (which could not be reached on foot). Stopping the Landrover and directing the headlights towards the bridge both men were shocked to see the beams of light pass straight through the figure which instantly vanished.

Stocksbridge by-pass road, northwest of Sheffield, is haunted by a monk and a circle of tiny dancing figures. (Photo: author)

Shortly before this terrifying incident, other weird and inexplicable happenings had taken place. According to the police the men

had seen "a group of young children playing just down from the bridge, near the new road around a pylon at about 12.30 at night, the same time as before. They drove past these kids, parked the Landrover, got out and found there was nothing there. They examined around the pylon, which was surrounded by fresh mud with no sign of footprints."

A Hillsborough man, John Holmes, was working at G.R. Steynes' lorry depot on Carr Road, Deepcar at the time. "When construction work was going on we heard kids singing on freezing cold nights and it was very frightening," he told me. "It started about 11 o'clock and continued to about two in the morning, almost like a small choir of about 10 or 12 kids. You couldn't tell what it was they were singing, but it was really spooky and you always had a strange feeling that someone was watching you. One old man at the depot refused to work nights because he had seen something there."

Mr Holmes was not alone in being "spooked". On the morning of September 8 the two security men, Brookes and Goldthorpe, turned up at the home of Stocksbridge vicar Rev Stuart Brindley (now vicar of Rotherham Parish Church). They woke him at seven o'clock in the morning, wanting to know if the road they were cutting through had once been a graveyard and whether an exorcism was possible. One of them later burst into tears and was said to have gone into shock – such was the effect of the experience.

Rev Brindley soon discovered the site had no connections with any Christian burial ground, and he phoned Ecclesfield Police Station to ask for help. The police there told me later how the security guards were "shaking like jelly, and begging for the vicar to do an exorcism, but he didn't know what to do and passed it on to us!"

At midnight on September 12 a dog handler, PC Dick Ellis and a special constable from Deepcar, both determined to get at the truth behind the story, drove up to the haunted road and parked beneath Pearoyd Bridge were the sighting had taken place. Both were hardened cops, sceptical about ghosts and the paranormal. Their views were soon to change.

"We parked the car up," PC Ellis told me afterwards. "We turned all the lights off and all the radios off. It was a clear night, clear sky, with a virtual full moon and after a while we could see great. We'd been sat there a couple of minutes and up by the bridge there was a large painted palate box and we could both see a shadow moving across it." PC Ellis flashed his police car lights onto the box, but there was nothing to be seen. The shadow appeared again, and the same thing happened. After a third appearance the two policemen began to wonder if it was the lights from the steelworks below which were causing the strange moving shadow. It was now after midnight and pitch black.

"We'd been sat there for about 20 minutes. It was a nice night and I put my window down," said PC Ellis. "Suddenly I had a peculiar feeling – not like I'd ever had before, because we have been working nights for a long time, just as if someone had walked over my grave, because I just froze . . . and what was so odd I went cold without knowing what was the matter. Then a few seconds after I had another feeling that someone was stood at the side of me, and I could see there was something stood by the side of the car. But as I turned there was nothing there, and it was then that my colleague let out such a scream and hit me on the arm. I looked around, and there was somebody stood next to the car!

"All I could see was his torso as he was stood next to the passenger window. By the time it had registered with me that someone was there it had gone. There was no way that anyone could have approached us without us seeing them. We then drove up to the bridge, parked and radioed to our colleagues at Deepcar to come and join us." Then something happened. "We'd been sat in the car for a few seconds, and then something thumped on the back of the car. Again there was nothing at all about, we could see too well and were out too quick to check it. The car didn't physically shake but something hit it. When this happened we drove back down to the works . . . "

Despite light-hearted ribbing from colleagues, PC Ellis was so disturbed about the sighting that he made an official report on the

"mysterious happenings" to South Yorkshire Police. When I spoke to him he stuck to his story, which he tells today in an honest, down-to-earth fashion. "There was definitely something there, but I can't explain it. I might have dismissed it as my imagination but my partner saw it and had the identical eerie feeling at the same time. It was definitely unnerving and it wasn't a publicity stunt as was claimed at the time – we don't do that sort of thing in the police force," he says.

When I asked PC Ellis to describe the figure he saw that night on the bypass, he said: "From what I saw of him, it sort of connected with the Victorian era. But I just looked at its face, which I presumed was a man, and it was just literally staring. Then we looked again and it was gone. Virtually it went from my side of the car to the other . . . as my colleague was looking out of his window I was just gazing up onto the banking, and I turned round and shouted . . . it was really weird. For a split second I saw his face, and it looked like he was wearing some kind of cravat and a waistcoat. It looked like something from Dickens. But as I looked again and tried to focus it was gone."

When stories about the strange happenings reached the Press, hundreds of people began to visit the bypass and Pearoyd Lane (which has become known as "the Ghost Bridge") to catch a glimpse of the phantom. There were few other authentic sightings that winter, but many people have come forward since to report strange sightings not only around Pearoyd Bridge, but on other sections of the road, particularly near the village of Wortley. Most of these people have described a phantom figure like a hooded monk, who has appeared in the middle of the road and even inside cars!

One of the strangest stories is that of a Chapeltown man, Graham Brooke, who had his experience in the autumn of 1987, again when the bypass was under construction. "I was training for the London marathon and my son came along for company. We had run to Wortley Church and we were coming back down the road when we both saw a strange apparition. It was so strange that at first our eyes could not take it in," he said. "It was

a man dressed in 18th century style clothing with a dark brown cape who carried a bag with a chain. The hair on our necks stood on end and there was a musty smell like an antiques shop. I turned to my son and said at first that it would get knocked down because it was on the road, but it just disappeared. If he had not seen it as well then I would not have said anything because no one would have believed me. I'm not superstitious but it was certainly an eerie experience which I can't explain."

This strange figure has been seen by many other people on the bypass and nearby Finkle Street, the road which links Wortley with Deepcar. Many of the witnesses have been visitors to the area who were not aware of the ghostly reputation of the place. A Barnsley man was working as a night driver for Ernest Thorpe's on Station Road, Deepcar, when he saw something strange one night in 1990. "I had pulled into the trailer park at Station Road and was taking the ropes off the back of the trailer when I suddenly went cold," he told me. "There was a musty smell and I saw a figure which looked like a monk gliding through the beam of the headlight. When I mentioned it to Peter Thorpe he said that other drivers had seen it as well."

Despite the many sightings of the ghost, there are in fact no records or stories which might cast light upon who or what he is. When pupils from Stocksbridge School decided to investigate the ghost in 1987 as part of an English and History project, they spoke to dozens of local people but gathered only vague stories about a suicide in a lonely house on the hillside. Their teacher, Irene Orchard said the most common local tale to explain the sightings was about a stage-coach taking the route from the local coaching inn on its way across the Pennines. "This had crashed, killing a group of small children," she wrote. "And tales of sightings of children dancing in a circle had been talked about in families for years."

Small dancing figures suggest the wee-folk or fairies, those ancient spirits of place who usually leave mankind alone unless disturbed. Another piece of folklore concerned the monk. He was said to have died in Underbank Hall, and was buried against his

wish in unhallowed ground miles from his monastery. His ghost, runs the story, haunts the area and has been disturbed by the building of the new road.

In 1993, after another driver lost his life on the dangerous stretch of road, a professional psychic from Penistone, June Beevers, came forward to say she believed the ghost of the monk was haunting the road and actually contributing to the hazards there. She is not the first psychic who has claimed contact with the ghost haunting the bypass, for a Wakefield woman contacted PC Ellis several years ago claiming to have communicated with it on a number of occasions. The ghost, according to June Beever's story, had materialised in the car next to her as she drove along the bypass. "I had a strange sense of fear and felt a presence in my car," she told a colleague. "A big black shadow was sat in the passenger seat. It didn't communicate with me but I felt a real sense of fear. I was shocked and I am used to psychic phenomena so it would be very startling for other drivers and I dread to think what the consequences would be." She added: "Every time I go to this stretch of road I feel this eerie presence and I believe these sightings could be related to the number of accidents that have occurred there."

June Beevers feels the ghost is malevolent, but so far no one has arrived at a convincing explanation for why he is appearing.

Already the ghosts of the Stocksbridge bypass are becoming part of the folklore of these mysterious moors, with stories told and re-told, passed from one generation to another, part of a process which has generated mythology and legend from the beginning of human history.

But the last word must go to psychic June Beevers. "I believe a lot of graves were disturbed when they built the bypass. A ghost is just a video stuck in time. It just repeats it actions over and over again. You can't communicate with it – it's just an impression of great emotion stuck in time."

9

UFOs over South Yorkshire

The "Flying Saucer Age" began on June 24, 1947, when American businessman Kenneth Arnold reported seeing a fleet of strange crescent-shaped objects moving "like saucers skipping across water" above the Cascade Mountains in Washington State, USA.

Over 45 years later the mystery of the flying saucers – or Unidentified Flying Objects (UFOs) as they have been called since 1957 – has grown into a world-wide puzzle of gigantic proportions. Despite many hundreds of thousands of sighting reports made by people from all walks of life, and just as many theories and explanations to account for them, experts are no nearer solving the UFO enigma today.

The most popular explanation for UFOs is that they are the spaceships of extra-terrestrial creatures from another galaxy who are visiting planet Earth to keep watch on humanity as human explorers might visit the moon or Mars. Many other theories have been put forward by the experts who study UFO reports (UFOlogists), and these include unknown exotic natural phenomena such as "earthlights" caused by electrical energy released by rock crystals, ball lightning, and complex hoaxes or hallucinations, misidentifications of stars and planets, even that they are time travellers from our own future.

Serious UFO researchers in Britain today accept that the most probable explanation for UFOs is a mixture of several of these theories. Jenny Randles, the country's only full-time UFOlogist, has said that 90% of sightings reported each year turn out to have a "down to earth" explanation, with less than 10% remaining

inexplicable. Of those remaining, it seems many are caused by exotic natural phenomena on the fringes of science.

Despite all the talk of aliens, most sightings are of lights in the sky, and one of the few clear patterns in the UFO data is the fact that reports seem to cluster around certain parts of the country, which have become known as "UFO Windows". The Pennine hills of northern England are one example, with many sightings repor- ted in the region stretching from Sheffield across to Bradford and North Yorkshire every year.

South Yorkshire in particular has been the scene of many UFO sightings since the 1950s. Large numbers of people spotted strange flying objects in the skies during the years 1962, 1967 and most recently during the great "wave" of sightings during the winter of 1987 – 1988 when over 200 sighting reports were made in Sheffield, Rotherham and Barnsley, many of them being fea- tured in the regional and national Press.

But the story should really begin on April 24, 1953, when the *Sheffield Telegraph* reported how three Wincobank schoolboys had seen what they described as "a flying saucer" in the evening sky. Terry Platts, Brian Davies and Allan Green, all aged 16 and living at that time on Newman Road, were watching pheasants in a field at Greasbrough Road about 7.30pm when they saw what they first thought was an aeroplane with the sun shining on it – until they realised there was no sun, it being a dull evening.

The UFO – "like two plates together" – approached them from the direction of Rotherham, moving fast but sometimes remaining stationary for several seconds. On these occasions, a reddish glow coming from behind it would cease. The large object disappeared after they had watched it for about 25 minutes. The object drawn by the three youths looks very much like the space rockets found in 1950s science fiction, as featured in the adventures of Buck Rogers and Flash Gordon. But Brian Davies' stepfather told the newspapers afterwards: "I'm convinced the boys aren't kidding. My son was too full of it for that. One boy says he couldn't sleep for thinking about it, although his father ridiculed him."

Whatever the case, the sighting was endorsed by no less an

authority than Waveney Girvan, then editor of the world-famous UFO magazine "Flying Saucer Review" (FSR), who featured the sighting in his book *Flying Saucers and Commonsense* published in 1954. Further sightings of unexplained lights and rocket-shaped objects were made in the city in 1959 and 1961, but it was not until 1962 that Sheffield made newspaper headlines as *the* place to see aliens!

That hectic year began with a sighting of a fleet of flying saucers at Mosborough, again reported by three schoolboys, this time 12-year-olds, Alex Birch and David Brownlow, who were playing at the time with 16-year-old Stuart Dixon. This report was different, for the boys were able to provide photographic evidence of the UFOs in the form of a single black and white still taken by Alex's box Brownie camera. The photo, later examined by experts who pronounced it to be genuine, showed five blurred saucer-shaped craft flying in formation above trees which oddly appear to be in sharp focus. In August, 1962, when the photos first appeared in the newspapers, Alex and his father were taken to London to discuss them with Air Ministry officials at Whitehall.

In 1962 flying saucers were hot news, and photographs which claimed to show them were much sought after. The Alex Birch photos were printed in newspapers and magazines across the world, and for a short time Alex became a celebrity guest at UFO spotters' conferences. The photograph would have been easily explained by UFOlogists today, who have access to high-tech computer technology as part of their rigorous investigation techniques. In the event, it took ten years for the boys to confess they had hoaxed the entire world.

It was not until October 1972 that David Brownlow admitted the picture was a fake. "It was just a joke that snowballed," he said. "We just got a piece of glass and painted five saucer-shapes on it. Then we took the picture. It's just unbelievable that everybody was taken in by it." And the photographer, Alex Birch, added: "The hardest thing is getting people to believe us now we've admitted it's a hoax. But it is true."

UFO photos today are not treated with the same enthusiasm as

they were in the 1960s and over the years many similar pictures have come and gone without providing that elusive "final proof" of outer-space visitors which many UFOlogists appear to be looking for. A very similar picture of three blurred saucer-shaped objects in formation above a fish and chip shop in Conisbrough, near Doncaster, taken by another schoolboy in 1966, probably has a similar origin.

The "cut and paste" method may have been used in the series of three photos taken by a Barnsley fisherman, in August 1987. These photos, depicting a classic saucer-shaped object flying above chimney pots on Sheffield Road, appeared first in the *Barnsley Chronicle*, and then on the front page of the tabloid *Daily Star*. However, computer enhancement by experts in Arizona, USA, later revealed this "UFO" was nothing but a piece or card or paper stuck onto a window pane.

The 1962 UFO Wave

In 1962 such was the excitement caused by the presence of aliens in the skies above Sheffield that a spate of other sightings were made in the three-week period following the appearance of the Alex Birch photos in the newspapers. One man even managed to take a cine film of a glowing saucer-shaped object which hovered above his terrace house in Walkley. "It was bright orange in colour and shaped like two soup plates, one upside down on top of the other. The main part of it was somehow translucent and the rim glowed even more brightly, like a neon sign."

This was how cutlery worker Walter Revill described the strange flying object he saw from the garden of his house on Walkley Street, Sheffield, just before 11pm on Sunday, August 19, 1962. That night he had been out for a drink with his friend, Mrs Teresa Spotswood, and when they returned she opened the back door of the house because it was a warm, close night. She stared in amazement at what she saw, and then called Mr Revill.

He told a reporter afterwards: "I saw it not very high and sailing slowly away over Woodside Flats. It was visible for nearly

a quarter of an hour and there was a brilliant light coming from it but no noise. I have never believed in flying saucers before but I am absolutely convinced this was one." After watching the object for several minutes, he dashed inside to fetch his cine-camera. The object had begun to move away rapidly and by the time he could begin filming it was just a receding point of light – but on developing the 10 feet of film he found he had indeed captured the strange object.

In the meantime, Mrs Spotswood had called two neighbours, Mr and Mrs Tony Pellegrina, who both saw the UFO and confirmed Mr Revill's description of it. Mrs Pellegrina said: "The saucer had lots of little lights as if somebody was inside. But it was not an ordinary plane, star or anything like that." That same night 25-year-old draughtsman Michael Waterhouse, of Woodseats, was driving near the City General Hospital at Fir Vale when his attention was drawn to a bright light in the sky. "We all saw it so we stopped to have a look," he said later. "It was very cloudy that night, and the thing appeared about a foot long, slightly domed at the top and bottom and it moved away and then came back."

When the colour cine film was developed the bright glowing object was visible on several frames, and black and white stills were later published in the *Sheffield Telegraph* and *Yorkshire Post* newspapers. "The film proves I wasn't imagining things," said Mr Revill. But unfortunately the Press and public were more interested in the Alex Birch photos, and the movie film from Walkley was given short shrift. The film was handed over to the then fledgling British UFO Research Association (BUFORA), who appear to have lost it before subjecting it to the thorough investigation it deserved. So much for photographic proof.

Experts at RAF Finningley and Lindholme Air Base told the Press in 1962 they were "baffled" by the spate of sightings over Sheffield, and could not offer an explanation. But Waveney Girvan of Flying Saucer Review gave his opinion that: "If there is life of any sort inside these flying objects, it presumably needs water to sustain it. It is likely that they have to collect water from the

earth for their return journey, and Sheffield is surrounded by reservoirs."

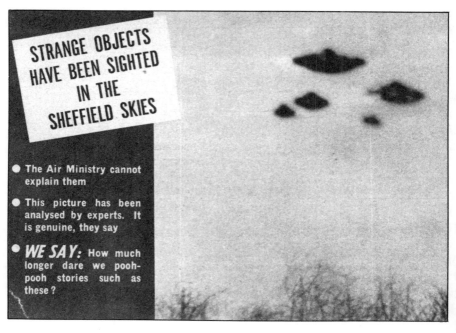

STRANGE OBJECTS
HAVE BEEN SIGHTED
IN THE
SHEFFIELD SKIES

● The Air Ministry cannot explain them

● This picture has been analysed by experts. It is genuine, they say

● *WE SAY:* How much longer dare we pooh-pooh stories such as these ?

Newscutting from 1962 describing UFO sightings in Sheffieldand South Yorkshire.

Since 1967 sightings of UFOs have been regularly. reported in South Yorkshire and Sheffield, and almost every year stories have appeared in the region's newspapers. Various UFO investigation societies have come and gone, and today's sightings are collected by a group of enthusiasts who stage an International UFO Congress in the city most summers.

Although most "sightings" are of lights in the night sky, there are many baffling cases of strange flying objects which have approached people in cars, hovered and even landed in South

Yorkshire. Sightings like these are described by UFO investigators as "close encounters", a term coined by an American astronomer the late Dr J. Allen Hynek, who once led the United States Air Force's official UFO investigation agency known as Project Blue Book. His classification "Close Encounters of the Third Kind" – the sighting of UFO occupants, was used by Steven Spielberg as the title of his 1978 blockbuster movie of the same name.

Close encounters with strange flying objects may be the stuff of Hollywood movies, but they continue to happen – or more accurately people claim they happen – in real life. During my ten years as a UFO investigator for two national organisations I have spoken to dozens of people who claim it has happened to them here in South Yorkshire. Here are just two of their stories:

Close Encounters

The Strange Tale of the UFO 'Road Runner' at Loxley.

As darkness fell one night in April 1977 a young Sheffield couple drove out to Long Lane, a lonely spot on Loxley Common which gives a picturesque viewpoint across the Bradfield Moors. Robert Holmes, the driver, parked his Morris Oxford estate near where the Loxley Country Club now stands as it meets Myers Lane, at around 9pm. Shortly afterwards, his girlfriend Sally Jensen heard "a crackling noise" and out of the rear window of the car they both saw a "bright orange light" appear a few hundred yards away. Robert originally thought the lights came from "a car with continental headlights" but soon they were terrified to see they shone out of a large "half-moon or dome-shaped object" which moved swiftly towards the frightened couple.

Worse still, silhouetted against the front of the object was "a large broad figure with a white haze surrounding its outline which appeared to have fizzy hair and furry boots". This apparition stood in the centre of a dome-shaped object, and appeared to stand fully ten or 11 feet in height! Understandably petrified, Robert switched on the car's ignition and immediately set off at

speed in order to escape from the uncanny object and its strange pilot. As their car roared along Myers Lane in third gear the flying object followed them, hugging the contours of the road as it travelled along.

"I was doing about 65 to 70 miles per hour," Robert told UFO investigator Nigel Watson afterwards. "But it was still catching us up . . . it seemed to be getting closer and closer all the time and I said 'I can't lose it'". Halfway down the lane they passed another car which had passed them earlier that evening and was now parked by the side of the road. As Robert turned right into the lane leading to Holdworth, the car's headlight blinked on in front of the UFO. Seconds later, peering back into the inky blackness of Myers Lane: "there wasn't anything there – it was pitch black; both the car headlights and the bright orange light had disappeared from view".

The couple were understandably shaken by their strange experience, but kept it to themselves until the following year 1978, when the movie *Close Encounters of the Third Kind* was released. It was only when the *Daily Express* newspaper set up a "UFO Bureau" for witnesses to report sightings to experts that the couple came forward to tell to their story, requesting that their real names be kept secret.

No doubt in the past, their uncanny experience would have become woven into folklore as an example of a confrontation with a ghost, boggard or some other malicious supernatural being. For although they did not know it at the time, this same area is haunted by the phantom White Lady who glides across Loxley Edge and along Myers Lane, holding her arms in the air . . .

Aliens over the Co-Op!

In 1978, it was still relatively rare for UFO witnesses in Britain to claim to have seen or contacted the occupants of flying saucers. But since that time, with the success of the films *Close Encounters of the Third Kind*, *Communion* and most recently *Fire In The Sky* stories about contact with aliens and the "abduction" of human

beings aboard their craft for medical examinations have become widespread, with thousands of people in the United States – and a small number in Britain – claiming it has happened to them.

Crop Circle, Greasborough, near Rotherham, 1991. A UFO landing or a hoax created by a pole and string? (Photo: Copyright Sheffield Newspapers)

Although no one in South Yorkshire has so far come forward with a story like that told by Whitley Strieber and Travis Walton in America, one of the strangest UFO cases I have investigated involves a Sheffield lady who saw what she describes as "a space machine" one evening in the spring of 1979 – hovering above a chip shop at Gleadless Town End!.

Mrs Jean Ford tells her story in a straight, no nonsense and convincing way. She does not care whether people believe her, but says she wants to know more about what was to her one of the strangest experiences of her life. "It was around dusk and I was walking along the road and met a neighbour called Ken and stopped to talk," she said. "We looked into the sky and saw a white light over a building which used to be the Co-Op but is now a video store.

"It was just like the sort of craft you expect to see – a saucer with a dome on top and a red light underneath which became dimmer. I could see machinery inside and two people, pale but human in shape wearing ice-blue uniforms. They had straight hair parted in the middle, but quite thick and clipped above their shoulders. The nearest I could think to describe it was to liken it to Cleopatra's hair. One man – I say he was a man, I don't know why – had his hands on what looked like controls and just stood there staring down. The other was at the side with his hands behind his back.

"I saw it for a couple of seconds, and afterwards my neighbour Ken said he saw the same thing but he was frightened about what people might think if we told anyone. I only saw him a couple of times after that but he never told his workmates."

Her curiosity about the sighting led her to visit the library, where a book by Jenny Randles put her in touch with BUFORA. When I spoke to her ten years afterwards the sighting was still clear and sharp in her mind. Most "close encounter" witnesses seem to have a sixth sense, a psychic ability, and their sightings seem to be only one event in a lifetime of otherworldly experiences. Mrs Ford is no exception, but that is another story.

"I do get upset when people don't believe it," she said recently.

"But at other times I think, Oh well, if that is what they want to think, but I think a lot of people laugh it off because it is so unbelievable. I will never forget what I saw, because when I think about it I can see the picture clearly in my mind. Before I saw it wasn't that I didn't believe, but I never believe until I have seen it myself and now I know. "

Whatever you believe, just remember that every year in Britain an estimated 10,000 people see Unidentified Flying Objects. So, never think that it cannot happen to you!

A Visitor's Guide to Strange South Yorkshire

Museums

Central Tourist Information Office: Peace Gardens, Sheffield S1 2HH. Telephone Sheffield 734671/2.

Weston Park Museum, Western Bank, Sheffield S10. Open all year, Tuesday to Saturday 10am to 5pm, Sunday 11am – 5pm, on 52 bus route from city centre. Telephone Sheffield 768588. Central museum of South Yorkshire, situated in a 19th century neo-classical building alongside the Mappin Art Gallery. There are archaeological displays from South Yorkshire and the Peak District, including Arbor Low and Stanton Moor. Particularly of interest for its display of carved stone heads of the Celtic tradition, Bronze Age cup and ring marked stones and a replica of the "Sheffield Cross".

The Traditional Heritage Museum, 605 Ecclesall Road, Sheffield. Open three times per year June 6, October 3, December 5, 2 – 5pm or by appointment. Phone Sheffield 768555 ext 6296. The Museum of the Centre for English Cultural Tradition and Language (CEC-TAL), features displays of local crafts, trades and lifestyles including cutlery, silversmithing, shoemaking, alongside exhibitions of local customs and folklore from South Yorkshire, Derbyshire and elsewhere.

Doncaster Museum and Art Gallery, Chequer Road, Doncaster. Open all year Monday – Saturday 11am – 5pm, Sunday 2pm –

5pm. Admission free. Includes collections of Roman finds, archaeology and natural history. Telephone Doncaster 734287.

Clifton Park Museum, Rotherham. Open all year Monday – Thursday and Saturday, 10am – 5pm, Sunday 2.30 – 5pm (4.30 October – March). Housed in 18th century mansion, includes displays of local history and Roman antiquities, including columns from Templeborough Roman Fort in courtyard.

Places of Historical Interest

Conisborough Castle, off main A630 Rotherham to Doncaster road (in care of English Heritage, admission charge). Telephone Rotherham 863329. Open all year, check with Visitor Centre for times. Remains of 12th century castle, probably built by Hamelin Plantagenet, in spectacular setting above the town in the valley of the river Dearne. It was the inspiration for Sir Walter Scott's novel *Ivanhoe*. During 1994, work began to rebuild a wooden roof and two floors inside the castle's stone keep, which is to be transformed into a reconstruction of life in a medieval castle, complete with visual and audio displays of scenes from the past. The history of the castle, which is billed as South Yorkshire's biggest tourist attraction with more than 30,000 visitors every year, is told in the adjacent Visitor Centre and guided tours are available.

Legends and traditions are many, including stories of hauntings by a ghostly white lady and a skeletal monk holding a candle. Underground tunnels are said to connect the grounds with Tickhill Castle and Doncaster. In Conisbrough town centre is the Anglo-Saxon Parish Church of St Peter, of possible 8th century origin and thought to be the oldest building standing in South Yorkshire. Built into the outside wall of the porch is a carving of a woman with a child in her lap which the castle guide says is a Roman stone depicting the Mother Goddess.

Sheffield Cathedral (St Peter and St Paul), Church Street. (City Centre) Open daily, with guided tours for visitors. Phone Sheffield 753434 for details. Of interest are carvings in the Lady

Chapel and Shrewsbury Chapel, Green Man, archaic-style carved heads, ghost and legend about underground tunnels (see chapter 1).

Sheffield Manor and Turret House. Manor Lane, Sheffield 2 (signposted from City Road). Visits by appointment with City Museum, Sheffield 768588, small admission charge. Ruined Manor House built on highest point in Sheffield Park by the Earl of Shrewsbury in 16th century. Mary Queen of Scots was held captive here and her ghost haunts the historic Turret House, built in 1574. Many stories about underground tunnels (see chapter 7).

Beauchief Abbey, Beauchief Abbey Lane, Sheffield. Open daily 10am – 7pm, key from cottage adjacent. Tel Sheffield 369886. Surviving part of 12th century abbey set in parkland. Stories of ghosts and underground tunnels.

Monk Bretton Priory, 17 Abbey Lane, Barnsley S71 5QD. (In the care of English Heritage, with admission charge). Telephone Barnsley 204089. Open April to September daily 10am – 6pm, October – March 10am – 4pm, Tuesday to Sunday. Extensive ruins of 12th century Cluniac abbey. Underground passages. Ghost in Mill of Black Monks pub on Grange Lane, Stairfoot, nearby.

Roche Abbey, Maltby, near Rotherham. Signposted from main road. (In care of English Heritage, with admission charge). Telephone Rotherham 812739. Open all year, April – September 10am – 6pm, October – March 10am – 4pm Tuesday – Sunday. Ruins of 12th century Cistercian abbey in beautiful setting beside Maltby Beck. Small exhibition of history. Many ghosts and legends, underground passages and lost wishing well.

Some Public Houses with Spirits!

Old Queen's Head, Pond Street, Sheffield. Adjacent to Transport Interchange. The oldest building in Sheffield, a Grade Two listed building dating to the early 16th century. Recently refurbished by new landlords, independent pub Tom Cobbleigh. Many tunnel

legends, several ghosts, and fine carved wooden heads dating from the Tudor period.

Carbrook Hall Hotel, Attercliffe Road, Sheffield (near Meadowhall Shopping Centre). Historic building on 13th century site with fine plaster and oak carvings. Four ghosts, including a English Civil War colonel.

Three Tuns, Silver Street Head (city centre, near Cathedral). A ghostly woman sobbing has been heard on a flight of wooden steps in the cellar, where there is evidence of a blocked up tunnel. The building dates back to early 1700s.

Manor Castle, Manor Lane (near Manor Lodge ruins). Said to be haunted by a ghostly white figure once described as "wearing gaiters and a plumed hat" (see chapter 6).

Cross Keys, Handsworth Road (near M1 Junction 33). Ancient building dating back to 13th century built in graveyard of nearby St Mary's Church, haunted by "grey lady". In cellar beneath tap room is entrance to a underground tunnel, said to run across main road to an old farm, via Manor Lodge.

Station Hotel, Aldwarke Road, Parkgate, Rotherham. Haunted by Eva Bostock, a spinster murdered nearby in 1936. Several landlords have experienced strange happenings in the pub cellar.

Saxon Hotel, Station Road, Kiveton Park near Rotherham. Haunted by a ghost known as Jasper, said to be a monk murdered here many years ago. He haunts the cellar and draws attention to himself by blowing a whistle!

Strines Inn, Bradfield (near Ladybower Reservoir). 15th century coaching inn on lonely moorland road. The driveway is haunted by a lady in white.

The Crofts, Quarry Hill, Mosbrough, near Sheffield. New pub opened in 1988 on site of 18th century farmhouse. Car park was haunted by a horse and cart which has been seen making a journey to a nearby pond.

Further Reading

Addy, S.O. *Sheffield Glossary and Supplement* (London, 1888); *The Hall of Waltheof* (London and Sheffield, 1893); *Household Tales and Other Traditional Remains* (London, 1895)

Alport, C.L. *The History of Conisbrough* (Sheffield, 1913)

Atkins, J *Myths of Stanyton and Surrounds* (Private, 1982)

Barnatt, J *Stone Circles of the Peak* (Turnstone Books, 1978)

Bostwick, David *Sheffield in Tudor and Stuart times* (Sheffield Libraries, 1985)

Clarke, David *Ghosts and Legends of the Peak District* (Jarrold, 1991)

Clarke, David & Wilson, R. *Strange Sheffield* (Private, 1987)

Eastwood, Rev J *The History of Ecclesfield* (London, 1862)

Gatty, Rev A *A Life at One Living* (London, 1894)

Hall, Muriel *More about Mayfield Valley and Old Fulwood* (Sheffield, 1974)

Harrison, John *A Survey of the Manor of Sheffield* (1637, reprinted 1906)

Hey, David *The Making of South Yorkshire* (Moorland publishing, 1979)

Holland, John *A Tour of the Don* (Sheffield, 1837); *Wharn-cliffe, Wortley and the Valley of the Don* (Sheffield, 1864)

Hunter, Rev Joseph *History of Hallamshire* (London, 1819); *South Yorkshire: History of the Deanery of Doncaster* (1828)

Leader, R.E. *Reminiscences of Old Sheffield* (Sheffield, 1876)

Magilton, J.R. *The Doncaster District:* An archaeological survey (1977)

Roberts, Andy *Ghosts and Legends of Yorkshire* (Jarrold, 1992)

Ryder, Peter *Medieval Buildings of Yorkshire* (Moorland publishing, 1982)

Salim, Valerie *A Ghost Hunter's Guide to Sheffield* (Sheaf publishing, 1983); *More Sheffield Ghosts and where to find them* (Sheaf, 1987)

Smith, Duncan & Trevor *South and West Yorkshire Curiosities* (Dovecote Press, 1992)

Tatton, Henry *Sheffield* (3 volumes), Sheffield City Libraries

Vickers, J. Edward *A Popular History of Sheffield* (EP Publishing, 1978)

Whitaker, Terence *North Country Ghosts and Legends* (Grafton, 1988)

Wilson, Rob *Holy Wells and Spas of South Yorkshire* (Private, 1991)

Contact Addresses

If you have enjoyed this book and want to find out more about Earth Mysteries, folklore, alternative archaeology or UFOlogy, you should begin by writing to some of the organisations and magazines in the list which follows. Always remember to enclose a stamped addressed envelope.

Northern Earth, the bi-monthly journal of the Northern Earth Mysteries group covers earth magic, ancient alignments, alternative archaeology, folklore and many other subjects covered by this book. The group hold regular meetings at places of interest and organise an annual "moot" (gathering) with speakers at venues throughout the north. For subscription details contact John Billingsley, 10 Jubilee Street, Mytholmroyd, Hebden Bridge, West Yorkshire HX7 5NP.

Mercian Mysteries, Earth Mysteries research in the Midlands, subscription details from Bob Trubshawe, 2 Cross Hill Close, Wymeswold, Loughborough LE12 6UJ.

The Ley Hunter, international journal of earth mysteries and geomancy, subscription details from P.O. Box 92, Penzance, Cornwall TR18 2XL.

Northern UFO News, bi-monthly journal edited by Jenny Randles, covers the latest UFO sightings in northern England. Subscription details from 37 Heathbank Road, Cheadle Heath, Stockport, Cheshire SK3 OLP.

The Centre for English Cultural Tradition and Language (CEC-TAL), Sheffield University, 9 Shearwood Road, Sheffield S10 2TD.

The centre began life as the Survey of Language and Folklore in 1964 and is now the principal national repository for material on all aspects of English Language and cultural tradition. Part of the Centre is the Traditional Heritage Museum, housed in a former church hall at 605 Ecclesall Road (see *Visitor's Guide*).

Readers wishing to report their own experiences with the unknown may contact the author at 6, Old Retford Road, Handsworth, Sheffield S13 9QZ.

Index

A

Abbeydale: *See Ghost Tunnel*
Addy, S.O. 14, 18, 21, 27, 30, 47, 49, 69, 76, 79
Aegil the Archer 4
Alport, C.H. 55
Anglo-Saxon Chronicle 53
Arbourthorne 111
Arnold, Kenneth 127
Arundel, Earl of 26
Askern 42
Athersley 45
Attercliffe Common 113, 115
Augustine 22
Austerfield 54
Axholme, Isle of 49, 51

B

Bailey Hill 20 - 22, 45, 62
Bakewell 4
ball lightning: *See UFOs*
Banner Cross 5
Bar Dyke 87
Barghasts 87
Barnatt, Dr John 17
Barnburgh 45
Barnett, Barry 117
Barnsdale 4, 26, 31
Barnsdale Forest 9
Barnsley 23, 24, 34, 35, 40, 46
Barnsley Chronicle 130
Barton, George 78
Basford, Kathleen 34
Baslow Edge 14
Bath 42
Bayeux Tapestry 53
Beardsley, Robbie 116
Beauchief Abbey 85, 95, 106, 107, 140
Beevers, June (Penistone) 126
Beltane (Celtic Festival) 4, 29, 38
Beowulf 4, 53, 67
Bevis, St 59

Birch, Alex 129
Birley Spa 42
Bishop's Tree 31
black dog: *See Barghasts/Boggards*
Blitz (December 1940) 64
bog bodies: *See sacrifice*
Boggans 50, 51
Boggards 87
Bole Hills 46
 See also Walkley
Bower, Robin Hood's 26, 28, 35
Boxing Day 11, 12, 73
Bradbourne 4
Bradfield 2, 17, 19, 22, 26, 30, 31, 34, 44, 62, 87
 Caking Day 71
 Strines Inn 142
Bradway 45, 46
Braithwell 23
Bramley Grange 97
Brigantia 1, 8
Bright, John 114
Brightside
 Devil Lane 113
 Hell Hole 113
Bright, Stephen 113
Brindley, Frank 100
 See also Ghost Tunnel; Sky Edge
Brindley, Rev Stuart 122
British Academy 64
British UFO Res. Assn: *See BUFORA*
Bronze Age 18, 38, 46, 49, 51, 106, 107
Brooke, Graham: *See Chapeltown*
Brookes, David 121
Broomhall 42
Broughton, Spence 115
BUFORA 131
Bull Week 80
Bunting Nook: *See also Boggards*
Bunting Norton 90
Burbage Brook 17
Burton-upon-Trent 54
Buxton 38, 41, 42, 46

C

Cakin Night 34, 70, 30, 71
Calderdale 30
Calvert, Frank 117
Cannon Hall 56
Cantley 23
Carbrook Hall Hotel 113, 115, 141
Castleton Garland Day 33, 36
Cawthorne 36
Cawthorne (near Barnsley) 56
Chapeltown 124
Charles II 37
Cholera Grounds: *See Manor Lodge*
Cholera Monument 111, 112
Christmas Customs 11, 72
 See also Bull Week, See Pagan magic
Clay Wood Quarry 111
Clifton Park Museum 140
clypping: *See St Peter's Church*
Coal Aston: *See Old Horse*
Coal Mining 116
Cock-Crowing Stone: *See Head Stone*
Conisborough Castle 97, 104, 141
Constantine, Emperor 46
Crofts, The (Mosbrough) 142
Crookes Feast 36
Cross Keys (Handsworth) 142

D

Daily Express, UFO Bureau 134
Daily Star 130
Danum: *See Doncaster*
Dart, River (Devonshire) 47
Dearne, River 24
de Busli, Roger 3, 19
Deepcar 45, 123, 125
 Station Road 125
de Lovetot, William 3, 5
Devil's Elbow 86
Dimbleby, Stephen 116
Dobbin Hill 85
Dodsworth, Roger 27, 44
Domesday Survey 3, 19, 23, 46
Doncaster 23, 31, 42, 45 - 47
 bogs 51
 Conisborough 55, 130
 Museum and Art Gallery 139
 Parish Church 47
 Roman Settlement 49
 Tickhill Grange 97
 Town Centre 104

Don, River 1, 47, 49, 55, 56, 62, 66, 67
Dore 1, 47
 See also Old Horse
Dore Enclosure Act 86
Dragon Hole, Nottinghamshire 54
Dragon of Wantley 48, 56, 59
Dragon's Den 64, 67, 68
 See alsoWharncliffe Crags
Dragon's Meadow, Beighton 54
Dragon's Well 64, 66
Dransfield 40
Dransfield, John 39
Dronfield 85
 See also Old Horse
Dungworth 72
 Cakin Night 70
 The Royal 71
dwarfs 87
Dwarriden 87

E

earthlights: *See UFOs*
Ecclesall 3, 85
 boundaries of 17
 Holmesfield 86
 Priest Hill 107
 witch hill 85
 Wood 4
Ecclesfield 3, 12, 19, 29, 31, 34, 85
 Church 21
 Police Station 122
 Priory 21
 witch hill 85
Eckington 61
Edward IV 60
Edward VI 37
Elizabeth I 4, 95
Ellis, PC Dick 122, 126
elves 87
Everton Church 55
Ewden Valley: *See More Hall*
Eyam 91

F

Fargate 6, 101, 103
Fearn, Frank 84
Filey Brigg 68
Fir Vale (General Hospital) 131
Freeman, Jeanette 118
Freya 46
Friar Tuck 26
Fulwood 17, 42, 107

G

Gabriel Hounds 90
Garner, Alan 105
Gatty, Rev 45
Gawain, Sir, the Green Knight 9, 10
George, St 55, 56, 59, 63
Ghost Quarry 112
Ghosts: *See Ley Lines; Stockbridge Bypass; Old Queens' Head*
Ghost Tunnel 102
Giant's Chair: *See Meggon Gin Hollow*
Girvan, Waveney (editor) 129
Glasgow Cathedral 44
Gleadless Town End 136
Goldthorpe 117
Goldthorpe, David 121
Goodfellow, Robin (Hob) 85
Graves Park 89, 107
Green Man, The 9, 12, 28, 33, 34
Grendel 49, 53
Grenoside 10
 Sword Dance 11, 74
Guilthwaite Hall 41
Gunthwaite Spa 39, 40
Guy Fawkes Night 69

H

Hackenthorpe 42
Hallam Moors 14
Hallamshire 2, 3, 18, 19, 21, 47, 60, 62
 boundaries of 17
 Lord of 3
Hall in the Ponds 91
Hallowe'en 69
Handsworth 2, 22
 See Handsworth Church; Old Tup; Sword Dances
Harold, King 53
Harrison, John 26, 27
Harrogate 41
Hartshead: *See Ghost Tunnel*
Hatfield 49, 52
Hathersage 17, 22, 30
 boundaries of 17
Haxey 51
Haxey Hood Game 50
Head Stone, The 14, 15
Heathershead 27
Helena, St 55
Henry I 62
Henry VIII 62

Hey, Dr David 12, 19, 23, 44
High Bradfield 45
Hinchcliff, Councillor Brenda 39
HMS Hood 79
Hole in the Road: *See Ghost Tunnel*
Holland, John 66, 91
Hollow Meadows 14
Holmesfield 22, 91
Holmesfield Castle 106
Holy Wells 44
Hones's Everyday Book 36
Hood, Robin 4, 25, 26, 28
Hooton Levitt 97
Hooton Roberts 88
Hordron Edge 17
Houndkirk Hill 86
Howard, Thomas 26
Humberside 49
Hunshelf Moor 120
Hunter, Joseph 3, 21, 47, 60, 100
Hynek, Dr J. Allen 133

I

Imbolc Festival 18
International UFO Congress 132
Iron Age 38
Ivanhoe: *See Conisbrough Castle*

J

Jack-in-the-Green 9, 34
Jackson, Helen, (MP) 120
Jack the Ripper 110
James, E.O. 51

K

Kenworthy, Joseph 44, 62, 66
Kimberworth
 murders 117
 Parish Church 119
King Arthur 91
Kirklees Priory 33

L

Lady's Bridge 47, 100
Lady Scope's Wood 118
Lambton Worm 59
Latimer, Bishop 37
Laughton-en-le-Morthen 25, 44, 97
Leader, J.D. 100
Ley line 106
Lindholme 49, 52, 131
 William of 49

Lindow Man 51
Little John 27, 30
Little Matlock 27, 31, 71
London
 Barnes Common 109
 Spring-Heeled Jack 113
Lovetot, William de 47
Loxley 29, 34
 Bradfield Moors 133
 'UFO Road Runner' 133
Loxley Edge 84
Loxley Firth Forest 26

M

Major Oak 33
Maltby 25, 54
Manor Castle 142
 underground passage 112
Manor Lodge 91, 99
 See also Old Queen's Head
Manvers, Earl 42
Margaret, St 55
Marion, Maid 26
Marr 46
Mary, Queen of Scots 6, 91, 92, 94 - 96
May Games 29, 30, 34, 36, 37
Meadowhall Shopping Centre 113
Meersbrook 1
Meggon Gin Hollow 86
Mercer, William 41
Mesolithic remains 42
Mexborough: *See Coal Mining*
Michael, St 55, 56
Midhopestones 44
Midsummer 19, 44
 Day 7
Midwinter
 Customs 72, 78
 Solstice 13, 16
Millhouses: *See Ghost Tunnel*
Monk Bretton 24, 140
Montgomery, James 11
More Hall 63, 57, 58, 66
Morris Dancers 34, 74
Mosbrough, The Crofts 142
Mother Goddess 1, 7, 47

N

Neepsend 49
New Year's Day: *See Old Tup*
Nicholson, Amy 118

Norfolk, Duke of 14, 93
Northend, W.F. 94
Nortin, Magathay 86
Norton
 Church 89, 104, 106
 Lightwood Lane 85
 St James Church 107
Norton Lees 89

O

Odin (Norse God) 30, 91, 113
Old Horse 79
Old Queen's Head (Sheffield) 93, 95, 96,
 141
Old Tup 76 - 78
Orchard, Irene (teacher) 125
Orgreave Colliery 115
Oughtibridge 48, 88

P

Park Ghost 113
 See also Spring-Heeled Jack
Park Hill Flats 112
Parson Cross 5
Pearoyd Bridge 120, 122, 124
Penistone 23, 39
Percy, Bishop 57, 64, 66, 67
Perret, R.D.Y. 107
Pitsmoor: *See Old Tup*
Pond Well Hill 42
 See also Old Queen's Head (pub)
Poole's Cavern 38
Porter Brook 12
Poynter, Edward 64, 68
Pratt, Rev. C.T. 56
Puritans 37

R

RAF Finningley 13
Redmires 46
Reeder, Phil 55, 67
Reformation 2
Ribble, River (Lancashire) 47
Ridgeway 46
Ringinglow 17, 90
Rivelin Forest 8
Roberts, Samuel 8
Roche Abbey 25, 97, 140
Romans 1, 30
Rotherham 14, 23, 25, 41, 44 - 46, 49, 5
 Advertiser 117, 118

Rotherham (contd.)
 All Saints Church 97
 Chapel on the Bridge 97
 Clifton Park Museum 140
 Coal Mining 116
 College of Jesus 97
 Hooton Roberts 88
 Parish Church 34, 122
 Roche Abbey 97
 Saxon Hotel 142
 Station Hotel 142
 Tunnels 93, 97
 UFOs 128

S

sacrifice 12
Salim, Valerie 83, 88, 89
Salvin: *See Old Tup*
Samhain (Celtic Festival) 4, 18, 69, 70
Saxon Hotel (Rotherham) 142
Saxons in England 49
Scathelocke 30
Serpent's Well 55
Seven Stones, The 17
Sharp, Cecil 11
Sharrow 84, 104
Sheaf, River 1, 2
Sheela-na-gig 7
Sheffield 2
 Beauchief Hall 85
 Blitz 68
 Broomfield 83
 Castle 3, 47, 94, 99, 101 - 104, 113
 Cathedral 3, 5 - 7, 10, 11, 17, 140
 Cholera Grounds 110
 Christmas Wassails 81
 City Council 42, 91
 Cross 4, 5
 Crown Court 102
 Ghosts of (book) 83
 Hartshead 101
 Lords of 6
 Machon Bank 85
 Manor 140
 Manor Lodge 94, 101
 Scotland Street 36
 Sheffield Telegraph 15, 27, 40, 109, 111
 Sheffield Independent 83
 Sheffield Star 99

Sheffield (contd.)
 Snig Hill 36
 St Mary's Church 14
 Traditional Heritage Museum 139
 Wadsley Common 84
 Worrall 88
Sheldon, Brian 115
Sherwood 26
Sherwood Forest 8, 33
Shirebrook Valley 42
Short, Dr Thomas 41
Shrewsbury, Earl of 6, 17, 91, 93, 95
Sigward the Strong 3
Silkstone 34
 All Saints Church 34
Silverwood: *See Coal Mining*
Simpson, Jacqueline (author) 67
Skelton, Phil 114
Sky Edge 111
 See also Brindley, Frank; Manor Lodge
Sparken Hill 85
Spence, Lewis 30
Spring-Heeled Jack 109, 112
Stannington
 Cakin night 70
 Fox & Glove 71
 Joe Atkins (historian) 70
 See also Gabriel Hounds
Stannington Club: *See Bull Week*
Station Hotel (Rotherham) 142
St Helen 45, 46
St John the Baptist 7
St Nicholas (High Bradfield) 19
Stocksbridge 44, 48, 59, 64
 bypass 120, 126
 School 125
 Steel Valley Walk 57
Stonehenge 106
St Peter's Church, Tankersley 18
Strafford, Thomas 97
Strieber, Whitley 136
Strines Inn (Bradfield) 85, 142
Stump John: *See Head Stone*
Sword Dancers 72
Sykes, Walter 119

T

Tatton, Henry 83, 111
Templeborough 1, 46
 Roman Fort 85, 113
tharf-cake 71

Theodore of Tarsus 76, 79
Thor (god) 76
Thorne Moss 50
Thornhill: See Old Tup
Thorpe: See Old Tup
Thorpe Hesley 45
Thorpe Salvin 2
Throapham 44
Thundercliffe Grange 74
Tickhill 3, 104
 Church 55
 Grange 97
Tinsley 118
Todwick 49
 Church 97
 Grange 97
Totley: See Old Horse
Traditional Heritage Museum 139
Tree of Life 9
Treeton 34, 41, 46
 Rotherham (Sword Dances) 73
Turret House: See Sheffield Manor
Turton, Kevin 119
Twelfth Day 50

U
UFOs 127, 129
Underbank Hall 125
Upperthorpe 36
 Whitehouse Lane 109

V
Vickers, Edward J. 99
Volund Saga 4

W
Wadsley 49
 Hall 104
Wakefield 30
Walderslow 63
Walkley 45, 69
 See Old Tup; UFOs
Walkley Bank 36
Waltheof, Earl 3
Waltheof, Hall 28
Walton, Travis 136
Wath Main pithead 116
Watkins, Alfred 33, 105
Watson, Nigel 134
wells and well-dressing 38, 44
Wentworth 45

Wentworth (family) 88, 97
Wentworth Woodhouse 74, 88
Westby, George 41
Weston Park 46, 84, 139
Weston Park Museum 139
 Bronze Age cup 139
 Sheffield Cross 139
 stone heads 139
Wharncliffe
 Chase 59
 Crags 33, 59, 62, 67
 Earl of 63
 Lodge 59, 64
Whirlow 16, 69
White Lady 134
Wickersley: See Old Tup
Wickersley Grange 97
Wigtwizzle 87
Wild Hunt 90
William the Conqueror 3
Will o'the Wisp 116
Wilson, John 30
Wilson, Rob 32, 40, 55, 106
 See also Graves Park
Wincobank
 Fort 113
 Hill 1
Winterhills 118
Winter Solstice 72
Woodall, Brian (Folklorist) 72
Woodhouse 23, 42
 See Old Tup; Sword Dances
Woodseats 46
Worksop Manor: See Mary, Queen of
 Scots
Worrall, Boggard Lane 89
Wortley 124, 125
 Hall 60, 64, 68, 74
Wortley, Sir Richard 60
Wortley, Sir Thomas 60
Wright, Jack 92

Y
York Minster 44

We publish a wide range of other titles, including general interest publications, guides to individual towns, and books for outdoor activities centred on walking and cycling in the great outdoors throughout England and Wales. This is a recent selection:

Cycling with Sigma ...

CYCLE UK! The Essential Guide to Leisure Cycling
— Les Lumsdon *(£9.95)*

OFF-BEAT CYCLING & MOUNTAIN BIKING IN THE PEAK DISTRICT
— Clive Smith *(£6.95)*

MORE OFF-BEAT CYCLING IN THE PEAK DISTRICT
— Clive Smith *(£6.95)*

50 BEST CYCLE RIDES IN CHESHIRE
— edited by Graham Beech *(£7.95)*

CYCLING IN THE LAKE DISTRICT
— John Wood *(£7.95)*

CYCLING IN SOUTH WALES
— Rosemary Evans *(£7.95)*

CYCLING IN THE COTSWOLDS
— Stephen Hill *(£7.95)*

BY-WAY BIKING IN THE CHILTERNS
— Henry Tindell *(£7.95)*

Country Walking ...

RAMBLES IN NORTH WALES – Roger Redfern
HERITAGE WALKS IN THE PEAK DISTRICT – Clive Price
EAST CHESHIRE WALKS – Graham Beech
WEST CHESHIRE WALKS – Jen Darling

WEST PENNINE WALKS – Mike Cresswell

STAFFORDSHIRE WALKS – Les Lumsdon

NEWARK AND SHERWOOD RAMBLES – Malcolm McKenzie

NORTH NOTTINGHAMSHIRE RAMBLES – Malcolm McKenzie

RAMBLES AROUND NOTTINGHAM & DERBY – Keith Taylor

RAMBLES AROUND MANCHESTER – Mike Cresswell

WESTERN LAKELAND RAMBLES – Gordon Brown *(£5.95)*

WELSH WALKS: Dolgellau and the Cambrian Coast
– Laurence Main and Morag Perrott *(£5.95)*

WELSH WALKS: Aberystwyth and District
– Laurence Main and Morag Perrott *(£5.95)*

WEST PENNINE WALKS – Mike Cresswell

CHALLENGING WALKS IN NORTH-WEST BRITAIN – Ron Astley *(£9.95)*

WALKING PEAKLAND TRACKWAYS – Mike Cresswell *(£7.95)*

– all of the above books are currently £6.95 each, except where indicated

If you enjoy walking 'on the level', be sure to read:

MOSTLY DOWNHILL, Leisurely Walks in the Lake District

MOSTLY DOWNHILL, Leisurely Walks in the White Peak

MOSTLY DOWNHILL, Leisurely Walks in the Dark Peak

Easy, enjoyable walking books; all £6.95

Long-distance walks:

For long-distance walks enthusiasts, we have several books including:

THE GREATER MANCHESTER BOUNDARY WALK – Graham Phythian

THE THIRLMERE WAY – Tim Cappelli

THE FURNESS TRAIL – Tim Cappelli

THE MARCHES WAY – Les Lumsdon

**THE TWO ROSES WAY – Peter Billington, Eric Slater,
Bill Greenwood and Clive Edwards**

THE RED ROSE WALK – Tom Schofield

**FROM WHARFEDALE TO WESTMORLAND:
Historical walks through the Yorkshire Dales – Aline Watson**

THE WEST YORKSHIRE WAY – Nicholas Parrott

– all £6.95 each

The Best Pub Walks!

Sigma publish the widest range of "Pub Walks" guides, covering just about every popular walking destination in England and Wales. Each book includes 25–30 interesting walks and varied suitable for individuals or family groups. *The walks are based on "Real Ale" inns of character and are all accessible by public transport.*

Areas covered include

Cheshire • Dartmoor • Exmoor • Isle of Wight • Yorkshire Dales • Peak District • Lake District • Cotswolds • Mendips • Cornwall • Lancashire • Oxfordshire • Snowdonia • Devon

... and dozens more – all £6.95 each!

General interest:

THE INCREDIBLY BIASED BEER GUIDE – Ruth Herman
This is the most comprehensive guide to Britain's smaller breweries and the pubs where you can sample their products. Produced with the collaboration of the Small Independent Brewers' Association and including a half-price subscription to The Beer Lovers' Club. *£6.95*

DIAL 999 – EMERGENCY SERVICES IN ACTION – John Creighton
Re-live the excitement as fire engines rush to disasters. See dramatic rescues on land and sea. Read how the professionals keep a clear head and swing into action. *£9.95*

THE ALABAMA AFFAIR – David Hollett
This is an account of Britain's rôle in the American Civil War. Read how Merseyside dockyards supplied ships for the Confederate navy, thereby supporting the slave trade. The *Alabama* was the most famous of the 'Laird Rams', and was chased half way across the world before being sunk ignominiously. *£9.95*

PEAK DISTRICT DIARY – Roger Redfern
An evocative book, celebrating the glorious countryside of the Peak District. The book is based on Roger's popular column in *The Guardian* newspaper and is profusely illustrated with stunning photographs. *£6.95*

I REMAIN, YOUR SON JACK – J. C. Morten (edited by Sheila Morten)
A collection of almost 200 letters, as featured on BBC TV, telling the moving story of a young soldier in the First World War. Profusely illustrated with contemporary photographs. *£8.95*